EDINBURGH AIRPORT

THROUGH TIME

Peter C. Brown

AMBERLEY PUBLISHING

I would like to thank the many people who have kindly contributed their images in order to lavishly illustrate this concise history of Edinburgh airport, and also Gerry Traynor of the 602 (City of Glasgow) Squadron Museum Association and Keith McCloskey for their assistance.

First published 2013

Amberley Publishing
The Hill, Stroud
Gloucestershire, GL5 4EP

www.amberley-books.com

Copyright © Peter C. Brown, 2013

The right of Peter C. Brown to be identified as the Author of this work has been asserted in accordance with the Copyrights, Designs and Patents Act 1988.

ISBN 978 1 4456 1537 0
ISBN 978 1 4456 1560 8

British Library Cataloguing in Publication Data.
A catalogue record for this book is available from the British Library.

Typeset in 9.5pt on 12pt Celeste.
Typesetting by Amberley Publishing.
Printed in the UK.

The Beginning

Until 1916 there were no military airfields in the Lothians. The Royal Navy had some emergency landing grounds in East Lothian for their coastal patrol aircraft flying from Montrose, and further possible landing sites had been identified for use as airfields and landing grounds around Edinburgh but it had not been taken any further.

The raid by the German Zeppelin airships L14 and L22 on Leith and Edinburgh on the evening of Sunday 2 April 1916 changed that.

The raid took British air defence completely by surprise, and so with little or no defence against the marauders, the attack continued into the early hours of Monday morning. Thirteen people lost their lives and more than twice that number were injured by the large numbers of high-explosive bombs and incendiary bombs that had been rained down over the city. As was the policy of the War Office at the time, news of the attack gave no location of where bombs had fallen, in order to prevent the enemy from identifying successful raids, but it was after this that the area around Turnhouse Farm was converted to a military airfield.

Situated on the old Edinburgh–Kirkliston road, 7 miles west of Edinburgh, in the County of Midlothian, Turnhouse opened as an aerodrome for the Royal Flying Corps in 1916 and was the most northerly British air-defence base in the First World War. It became operational when No. 26 (Reserve) Squadron was formed there on 22 May; its aircraft were stored under the shelter of canvas hangars until the first permanent hangar was built later in the year. Being situated next to the main Edinburgh–Dundee railway line enabled the early flying machines to be delivered by rail and assembled on-site.

In May, No. 36 (Home Defence) Squadron arrived from Cramlington and stayed until 12 October when they moved to Hylton.

Early January 1917 saw the formation of two Canadian squadrons at Turnhouse; in January, 84 (Reserve) Squadron was formed

and left for Toronto in the following month and on 15 March, 89 (Reserve) Squadron was formed and transferred to Beverley on 18 April.

On 13 April 1917 Turnhouse became home to No. 77 (Home Defence) Squadron, which was formed for the defence of the Firth of Forth against enemy night raids. Commanded by Major W. Milne, MC, the squadron was equipped with BE2c, BE2e, BE12 and BE12b aircraft, and arrived from the airfields at New Haggerston, Whitburn and Penston.

No. 73 (Training) Squadron arrived from Thetford with their Sopwith Camels on 17 September, replacing No. 26 Training Squadron as the Reserve Squadron had now become. They were re-equipped with Avro 504Ks, which had been modified for night-flying, and remained at Turnhouse until 20 February 1918 when they departed for Beaulieu, Hampshire.

Following the departure of nos 73 and 77 squadrons, the aerodrome, which at this time covered an area of 149 acres, became a Fleet aircraft base under command of the Commander-in-Chief of the Grand Fleet, and was known as RAF Turnhouse when the Royal Flying Corps and the Royal Naval Air Service (RNAS) merged to form the Royal Air Force on 1 April 1918.

RAF Turnhouse was at this time comprised of a grass landing strip 1550 yards x 450 yards, with one 130 feet x 120 feet Home Defence pattern hangar, three 1915 pattern hangars – two measuring 200 feet x 70 feet and one measuring 150 feet x 70 feet – and one 1916 pattern hangar of 170 feet x 80 feet, and during 1919 it was used solely as a fleet aircraft repair and practice depot with only one operational squadron (104) using it as a base for a short period of time.

Towards the end of 1919, the Ministry offered Turnhouse Farm and the aerodrome (covering 178¼ acres) 'for disposal as a whole, or the buildings and land on which they stand'. This spurned an angry response by Archibald Philip Primrose, the Earl of Rosebery, which was printed in the pages of *The Scotsman* and was the beginning of a lengthy period of correspondence between himself, Sir Howard Frank and others, relative to the right of the Ministry of Munitions to dispose of Turnhouse Farm.

83 Squadron, a daytime bombing unit equipped with Hawker Hinds, was formed at RAF Turnhouse on 4 August 1936, and a station headquarters at RAF Turnhouse was formed under the command of Squadron Leader Lord G. N. Douglas-Hamilton, AAP.

On 5 October, Flying Officer M. F. B. Read from 83 (B) Squadron was attached for duty as Station Adjutant.

On 2 January 1937, Squadron Leader D. A. Boyle took over command of the station headquarters, and Flight Lieutenant G. N. F. O'Brien, DSC, took over as Station Adjutant on the 21st.

Wing Commander W. K. Mercer assumed command of the station on 1 February, and on the 27th 83 Squadron moved to the armament training camp at Leuchars for a month of exercises, returning on 26 March.

On 5 July, a detachment of 200 RAF and AAF officers and airmen, under the command of Wing Commander W. K. Mercer, lined part of the route on the occasion of the state entry of Their Majesties King George VI and Queen Elizabeth into Edinburgh, and on 28 July, two flights of 83 Squadron formed part of the escort for Their Majesties on the occasion of their visit to Northern Ireland.

On 4 December, Wing Commander W. K. Mercer was posted to the RAF station at Kenley, and was replaced by Wing Commander G. S. Oddie, DFC, AFC.

In February 1938 one of 111 Squadron's new Hurricanes, flown by Squadron Leader J. W. Gillan, set a record for the Turnhouse–Northolt trip of 327 miles in 48 minutes at an average speed of 408.75 mph. The attempt deliberately coincided with a strong tailwind but his navigation must have been incredibly accurate. Many years later, in August 1954, Squadron Leader R. L. Topp flew the same route in a Hunter of 43 Squadron in 27 minutes and 46 seconds, an average speed of 717 mph.

On 9 March, 83 Squadron were transferred to RAF Scampton, Lincolnshire, where they remained through the first six months of the war, having been re-equipped with the Handley Page Hampden in November 1938.

On 15 April Wing Commander G. S. Oddie, DFC, AFC, was posted to RAF Boscombe Down and, upon his departure, the station headquarters at Turnhouse was closed.

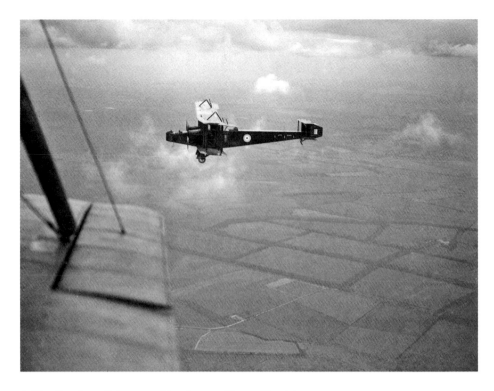

A Handley Page flying near Turnhouse. (Henry Harris)

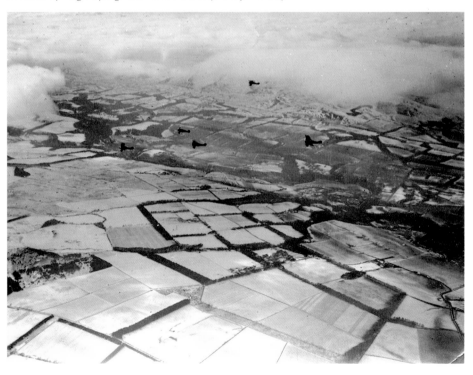

Sopwith Camels from Turnhouse in late 1918. (Henry Harris)

RAF Station Turnhouse on 30 April 1919. (Henry Harris)

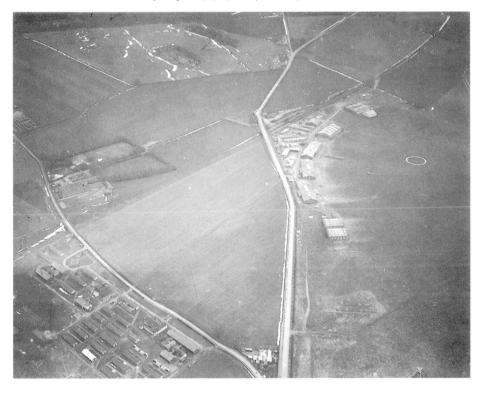

Another view of RAF Station Turnhouse on 30 April 1919. (Henry Harris)

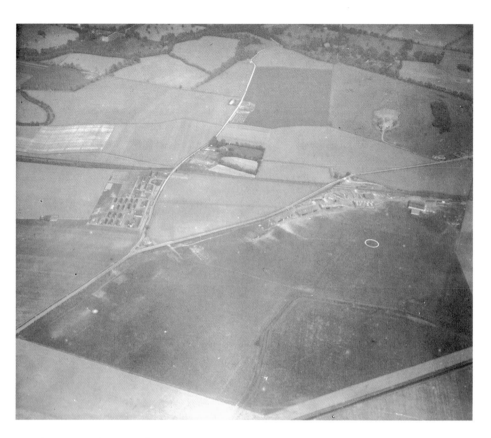

Turnhouse aerodrome and camp on 16 May 1919. (Henry Harris)

The Second World War

RAF Turnhouse became a Sector station of 13 Group from the outbreak of the Second World War and was home base to many squadrons of the Royal Air Force and the Fleet Air Arm. The opportunity had been taken to lay three concrete runways to replace the worn and poorly drained grass landing strips. They were 13/31 (3,900 feet), 08/26 (3,300 feet) and 04/22 (2,100 feet), with 08/26 being the most frequently used because it was aligned into the prevailing wind. The undertaking was not only to provide firm runways for its current use as a military airfield, but with a view to favouring the future of Turnhouse as a civil airport.

On 3 September 1939 a signal was received from Group at 1121 hours:

> War Declared by GREAT BRITAIN on GERMANY. Station Headquarters in process of peace-time formation under command of Wing Commander D. M. Fleming as Sector and Station Commander. Station is allocated to No. 13 Group Fighter Command.
> Operational Flying Units are:-
> 1. Turnhouse. One Auxiliary Squadron (603) commanded by Squadron Leader E. H. Stevens, AAF
> 2. Abbotsinch. One Auxiliary Squadron (602) commanded by Squadron Leader A. D. Farquhar, AAF.

These squadrons were embodied on 23 August 1939 and fully mobilised on 1 September.

603 (City of Edinburgh) Auxiliary Air Force Squadron (AAF), which chose as its motto the Doric words 'Gin ye Daur' or 'If you Dare', had been a day-bomber group until 1938 when it became a fighter unit, and was active in two flights and a training and communication flight under the command of Squadron Leader E. H. Evans, AAF, within two

9

weeks of the outbreak of the Second World War, using Avro 504Ks for flying training and operating De Havilland DH9As, Westland Wapitis, Hawker Harts and Hawker Hind light bombers.

A detachment of the 3rd (City of Edinburgh) Women's Auxiliary Air Force (WAAF) Company reported for duty, which brought the strength of the station headquarters (with 603 Squadron) at RAF Turnhouse to 505 personnel.

The motor transport at the outbreak of the war were various Crossley, Albion, and Leyland lorries, two Albion fuel tankers and three 450-gallon petrol trailers, a 3-kw Landmark beacon, a 4-kw Floodlight trailer, a Fordson tractor, various tenders and an Albion ambulance.

Guard duties and defence of the aerodrome were carried out by a detachment of sixty-nine regulars of the 4th Battalion, King's Own Scottish Borderers. Their duties included the maintenance of three anti-aircraft posts of double- and single-mounted Bren guns and operating three patrols between 2000 hours and 0800 hours for the protection of aircraft on the south-western boundary of the aerodrome. Three anti-aircraft posts at strategic points of the aerodrome were equipped with Lewis guns and manned by RAF personnel.

The aircraft had all been dispersed around the perimeter of the site since 24 August, and the pilots were accommodated in tents at their relative dispersal points.

Work was well in advance on the extension of the aerodrome and the erection of the non-technical buildings (the barrack block and canteen, etc.) on the north side of the main road boundary. Part of the aerodrome had already been camouflaged and nets were being prepared to obscure the outlines of the main buildings.

On a daily basis, Group assumed control of operations at RAF Turnhouse from 0800 hours and it returned to Sector Control at 2000 hours; give or take thirty minutes or so, this trend continued throughout the war.

In early October 1939, 141 Squadron re-formed at RAF Turnhouse with Gloster Gladiators and later Bristol Blenheims for training, but in early 1940 was re-equipped with the Boulton-Paul Defiant Mk I. The squadron was declared 'operational' on 3 June, and flew on convoy escort missions in the North Sea until moving to RAF West Malling in July.

From 7 October, the aerodrome defences were strengthened by the erection of barbed-wire fences around the outer perimeter, and around the petrol dump under supervision of the Royal Engineers. For this purpose 5 tons of barbed wire were used, and the scheme was completed by 27 October.

The first air raid on Britain took place on 16 October 1939, and took the British air defence completely by surprise. No alarm was sounded and the performance of the early-warning system gave serious cause for concern as the Royal Navy ships in the harbour at Rosyth were attacked by a formation of Junkers Ju-88s of 1/KG30 from the Luftwaffe airfield on the island of Sylt.

HMS *Repulse* had entered Rosyth three days earlier for a boiler clean and was still in dry dock when the raid took place. HMS *Hood* was about the enter dry dock for repairs at Rosyth, but a personal order from Hitler forbade any attack on the vessel, stating, 'Should the *Hood* already be in dock, no attack is to be made, I won't have a single civilian killed.' However, German intelligence identified the wrong ship (the *Repulse*).

Taking the advantage of cloud, the raiders adopted dive-bombing tactics and released around forty bombs. During the raid, HMS *Southampton* was damaged, and sixteen crew onboard HMS *Mohawk* were killed including the ship's captain, Captain Jolly, who, although mortally wounded, stayed at his post until his ship was safely docked.

Spitfires of 602 (City of Glasgow) Squadron from RAF Drem and 603 Squadron from RAF Turnhouse engaged the enemy aircraft; Flight Lieutenant George Pinkerton of 602 Squadron shot down a Junkers Ju-88 near Crail, which thus became the first enemy aircraft to be brought down by RAF Fighter Command, and another was caused to crash into the sea off Port Seton.

On 18 October, No. 946 (BB) Squadron (AAF) flew their first balloon barrage (four flights of eight balloons) from the south side of the Dalmeny School, and on 27 October, a second Barrage Balloon Squadron (No. 948, AAF) flew their first balloon of the new barrage from 'Site 22' – on the north side of the Forth Bridge.

'Red' Section of 603 Squadron was in battle on 22 October, shooting down a Heinkel He-III that was part of a formation attacking a convoy; it went into the sea around 7 miles off St Abb's Head.

On 28 October, 603 Squadron and 602 Squadron (flying from RAF Drem) sighted enemy aircraft while on patrol at 14,000 feet over the Firth of Forth. One of the raiders, which proved to be a new type Heinkel He-III, was brought down near Kidlaw, around 6 miles south of Haddington. One Spitfire from 602 Squadron was damaged by returning gunfire but landed safely, though it was later written-off; the pilot was unhurt. 603 Squadron left RAF Turnhouse for RAF Prestwick on 16 December.

By the end of 1939, RAF Turnhouse had additional strength with the detachment of ninety men from the 55th and 60th Light

Anti-Aircraft Brigades and ninety-three soldiers of the Royal Scots Regiment. It subsequently became the home of the Turnhouse Sector Operations Room and staff (twelve WAAFS were posted to the station as plotters).

During 1940, Turnhouse was home to several squadrons: 263 Squadron arrived with Gloster Gladiators on 3 May, a day before the new runways on the aerodrome were passed serviceable, and the following day, 603 Squadron returned from RAF Drem, though it was soon split up – 'B' Flight moved to RAF Montrose on 21 June, and 'A' Flight moved to RAF Dyce on 30 June. On 15 May, the aerodrome ground defences were further enhanced with the arrival of four 20-mm Hispano Shell guns, and on 1 July 245 Squadron arrived (staying until 20 July).

On 18 July, Wing Commander His Grace The Duke of Hamilton & Brandon, AFC, was posted from headquarters, 11 Group, to command RAF Turnhouse. 253 Squadron arrived on 21 July from RAF Kirton-in-Lindsay, having just been re-equipped with Hurricanes. On 23 July, 603 Squadron returned for a four-day stay before moving to RAF Hornchurch.

253 Squadron left Turnhouse for Prestwick and were replaced by 65 (East India) Squadron from RAF Hornchurch on 28 July, taking a well-earned respite from the air battles raging in the south and flying routine patrols and convoy escorts. They were joined on 30 August by 141 Squadron from RAF Dyce and RAF Montrose.

On 12 September, 'B' Flight of 141 Squadron left for RAF Biggin Hill, and during the next day 65 Squadron arrived from RAF Hornchurch. They were joined in the same month by nos 1 and 3 squadrons.

3 Squadron left Turnhouse on 8 October; 'A' Flight moving to RAF Dyce and 'B' Flight to RAF Montrose, and were replaced on 11 October by 607 Squadron. On 15 October, the remaining Flight of 141 Squadron moved out to RAF Drem.

On 8 November, the aerodrome was unserviceable owing to the work that was started on an extension of the runway to the eastern end of the perimeter track. As a consequence, 65 Squadron was moved to RAF Leuchars and 607 Squadron to RAF Drem. Bad weather delayed work on the runway extension, including a complete stop caused by the first fall of thick snow at the end of the year.

603 Squadron returned to RAF Turnhouse from RAF Drem on 1 March 1941, and were joined on 21 April by 213 (Hurricane) Squadron.

Two new Spitfire squadrons were formed at RAF Turnhouse in early 1941 to carry out convoy patrols in the Firth of Forth: 122 (Bombay)

Squadron on 1 May, moving out to RAF Ouston on 27 June, and 123 Squadron on 10 May to provide shipping escorts and patrols along the Scottish east coast and the Forth Estuary. The squadron also facilitated the training of new pilots, exposing them to operational flying, before moving to RAF Drem on 6 August.

603 Squadron left RAF Turnhouse for RAF Hornchurch on 16 May, and were replaced the following day by 64 Squadron.

On 18 May, 213 Squadron left Turnhouse for embarkation overseas, and on 24 May 64 Squadron left for RAF Drem.

On 24 June, Squadron Leader G. F. Chater, DFC, assumed command of RAF Turnhouse from Group Captain HG The Duke of Hamilton & Brandon, AFC.

On 6 August, 64 Squadron arrived from RAF Drem, returning there on 3 October. They were replaced by 312 (Czech) Squadron who arrived with their Hurricanes (and were soon to be re-equipped with Spitfires) from RAF Ayr. They left RAF Turnhouse on 28 November.

On 7 November, 340 Squadron, the first Free French Fighter Squadron, was formed at Turnhouse and became operational with Spitfire Mk Is in two flights – 'A' Flight ('Paris') and 'B' Flight ('Versailles') – on 29 November, flying defensive patrols. The squadron moved to RAF Drem in 1942 to carry out fighter sweeps over northern France.

Personnel from 81 Squadron arrived at Turnhouse in December to train up on Spitfires. They had just returned from Russia where they had flown its Hurricane aircraft from HMS *Argus*, deploying them at an airfield near Murmansk for the Russians to train their pilots, fly defensive sorties and escort missions for Soviet bombers. They became operational on 1 February 1942, and on 11 April left for RAF Ouston.

No. 4 Delivery Flight was based at Turnhouse from 8 January 1942 to ferry fighter aircraft to airfields within 11 Group.

April saw 242 Squadron re-formed with Spitfires at Turnhouse with Canadian pilots following its collapse through lack of spares at Palembang on Java. They carried out coastal patrols and left on 15 May. They were then deployed to North Africa in the defence of Algiers.

From early 1942, several squadrons of the Fleet Air Arm (FAA) were attached to Turnhouse; these were usually disembarked from aircraft carriers in the Firth of Forth.

801 (FAA) Squadron were the first to arrive with Hawker Sea Hurricanes, and in May left on HMS *Argus* to take part in the Malta Convoys.

808 Squadron followed with Fairey Fulmars; 882 Squadron with Grumman Martlet Mk Is (and transferred to RAF Machrihanish, near Campbeltown, in mid-March); and 884 Squadron arrived with Supermarine Seafires (until 6 July when they left for RAF Peterhead).

On 20 May, RAF Turnhouse provided the new headquarters for 289 Squadron, which had moved from RAF Kirknewton where it was formed on 20 November, and it remained until 7 May 1945. They worked in cooperation with anti-aircraft batteries in the area with Hurricanes, Oxfords and Defiants.

On 18 July, 116 Squadron arrived from RAF Heston. Equipped with Westland Lysanders and Tiger Moths, their job was to fly its aircraft around the anti-aircraft batteries in the area to allow them to make sure that their equipment was properly calibrated and thus accurate.

In August, 886 (FAA) Squadron joined RAF Command at Turnhouse with its long-range Fairey Fulmar Mk IIs until it moved to RAF Peterhead, and then to RAF Stretton, in October. The squadron returned again and spent most of 1943 at Turnhouse, being re-equipped with the Supermarine Seafire Mk LIIC in March. In June 1943 the squadron had added a Fairey Swordfish Mk II to its numbers and embarked on HMS *Attacker* to take part in the Salerno landings in September.

On 1 September, 232 Squadron arrived from RAF Debden. 232 and 242 Squadrons left RAF Turnhouse on 24 November for North Africa.

On 27 October, 2770 (Light Anti-aircraft) Squadron of the RAF regiment arrived from RAF Grantham.

The second Free French Squadron (341) was formed at RAF Turnhouse with Spitfire Mk Vbs on 15 January 1943, moving to RAF Biggin Hill in March. The squadron spent the latter part of the war on the Continent, returning to Turnhouse in February 1945 for a few weeks before going overseas on armed reconnaissance missions over German-occupied territory.

895 (FAA) Squadron arrived in June from RAF Machrihanish with their Seafire Mk IICs and were disbanded to form 816 and 842 (FAA) Squadrons.

On 25 July, No. 63 (Tactical Reconnaissance) Squadron arrived with their North American Mustangs to participate in intensive training exercises before moving to RAF Thruxton in November. 808 (FAA) Squadron left Turnhouse on 20 August.

On 21 August, Wing Commander T. L. E. B. Guinness, OBE, reassumed command of RAF Turnhouse from Squadron Leader H. J. Riddle.

268 Squadron arrived in November 1943 with their Mustangs, flying tactical reconnaissance missions over northern France. They left on 16 January 1944 and were replaced the following day by 63 (Mustang) Squadron.

Towards the end of the war, RAF Turnhouse had become a favoured destination for rest and recreation, not least for the American aircraft, which quickly filled the landing ground to the displeasure of RAF staff.

63 Squadron returned to RAF Turnhouse in January 1944 and was re-equipped with Hurricanes for training in bombardment spotting with the Royal Navy, pending attachment to the D-Day Landing Forces in May 1944.

In February 1944 the Air Ministry were made aware of the interest shown by Edinburgh Corporation in providing civilian air services from RAF Turnhouse after the war, and took note while replying that no decision had yet been made.

On 27 April, 63 Squadron (and their servicing echelon) left RAF Turnhouse for RAF Woodvale.

290 (Target Towing) Squadron arrived from RAF Long Kesh the following day with Oxfords, Martinets and Spitfire Mk Vbs to provide target and attack simulations for continuation training for anti-aircraft units over Scotland. This continued until January 1945 when the squadron was posted to Belgium.

On 6 September, twenty-one Avengers of 848 (FAA) Squadron arrived for ten days to practice deck landings.

In March 1945, 329 (Spitfire) Squadron arrived for a brief stay at RAF Turnhouse, having been withdrawn from the Continent. They left for RAF Skeabrae the following month.

In April, No. 88 Group of the Allied Expeditionary Force established itself at Turnhouse involving elements of 330, 333 and 334 (Reconnaissance) squadrons of the Royal Norwegian Air Force.

603 Squadron also arrived in April, finally returning home from the war. In May, their Spitfires escorted a special flight of three Junkers Ju-52s to RAF Drem. On board were representatives from the three German Services in Norway to offer the surrender of troops and to make arrangements for the end of the occupation.

603 Squadron were later disbanded on 15 August, and re-formed at Turnhouse in 10 May 1946 with Spitfire Mk XVIEs.

In June, 164 Squadron arrived from overseas to re-equip with Spitfire Mk IXs, and left in November for RAF Fairwood Common, returning in January 1946 for a few months.

On 26 September, the airfield was entirely closed to enable completion work on the runway intersection.

In October, operational control of RAF Turnhouse was transferred from RAF Fighter Command to the Reserve Command, and subsequently control of Turnhouse was then passed from the RAF to

the Ministry of Transport & Civil Aviation. The airfield was closed on 20 October to enable work to be done on runway 26/08.

On 31 October, Group Captain The Duke of Hamilton & Brandon, AFC, and Wing Commander Lord Malcolm Douglas Hamilton, OBE, DFC, visited the station.

By 26 November 164 Squadron had moved to RAF Fairwood Common, and 303 (Polish) Squadron arrived with their Mustang Mk IVs on 28 November. They remained until 4 January 1946, when they were posted to RAF Wick. 303 was the squadron that scored the highest number of enemy 'kills' during the Battle of Britain. They were joined by 6303 (Polish) Servicing Echelon from Andrews Field.

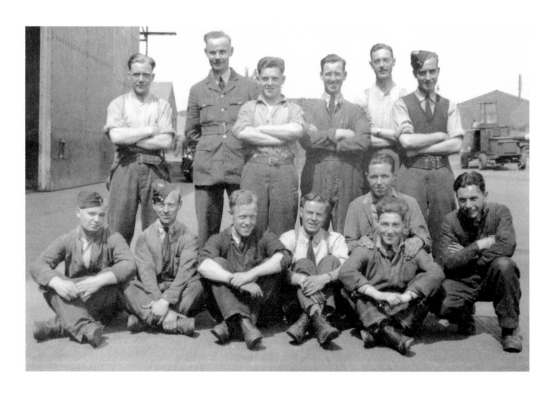

603 Squadron Hangar Crew at Turnhouse. Back row left–right: Tom Davidson (mechanic), Simpson (radio/electrician), Roy Gray (mechanic), Frank Feeny (rigger), Young (radio/electrician), Jock Towsey (mechanic). Front row left–right: Jackie Crooks (mechanic), Jock Penny, Willie Kidd, Harry Ross, Chic Cessford (kneeling behind Harry Ross), Lew Erskine, Alex Wishart. (Scott Wishart)

On 16 October 1939, German bombers attacked the naval base at Rosyth on the Firth of Forth. They also attacked the Forth Bridge, over which a train was passing at the time, without result. (J&C McCutcheon Collection)

Right: The Heinkel III that was shot down on 16 October 1939. (Malcolm Vardy)

Below: Members of the RAF escorting the coffins of two German airmen killed in the raid, watched by a crowd including women and children carrying gas masks. (J&C McCutcheon Collection)

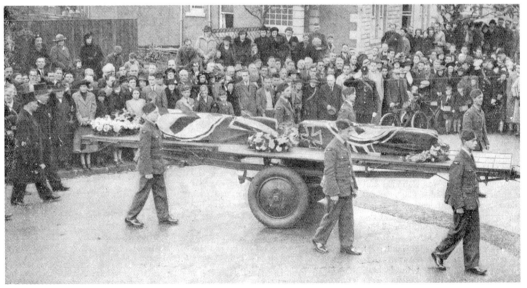

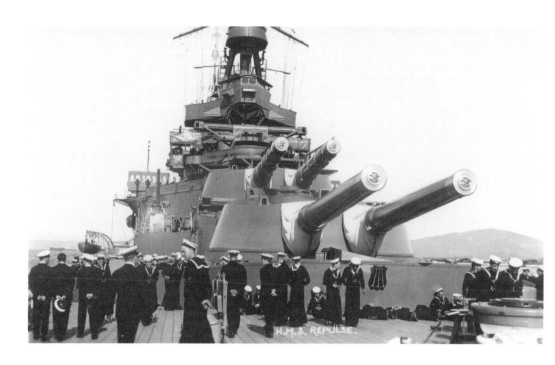

The Royal Navy battlecruiser HMS *Repulse*, above, was in dry dock at Rosyth when German aircraft attacked on 16 October 1939. (J&C McCutcheon Collection) German intelligence mistook her for HMS *Hood*, on which Hitler had forbidden an attack for fear of civilian casualties. She is marked with an arrow in the aerial photograph of Rosyth shown below. (Gerry Traynor)

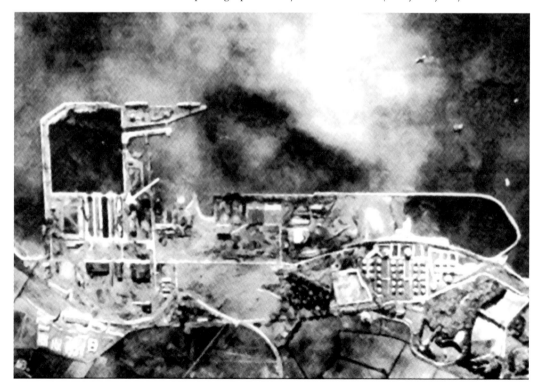

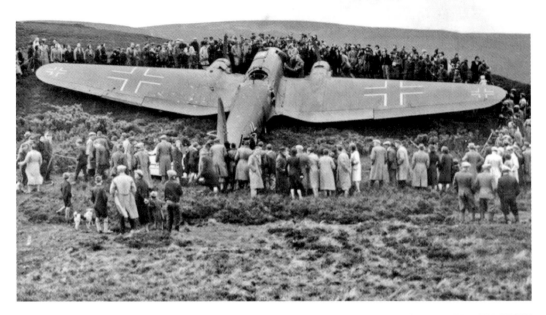

Above: The 'Humbie Heinkel' that was brought down by 602 Squadron on the Lammermuir Hills on 28 October 1939. (Gerry Traynor)

Right: An RAF officer standing beside bullet holes in the fuselage of the Heinkel. (J&C McCutcheon Collection)

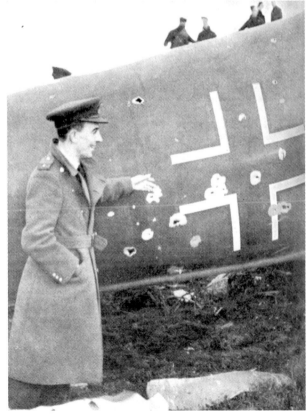

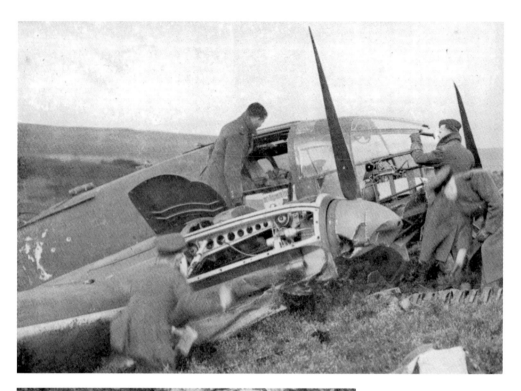

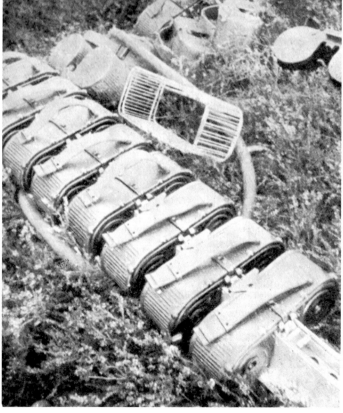

Above: Experts from
the RAF examining
the damaged nose and
cockpit of the Heinkel.
(J&C McCutcheon
Collection)

Left: Machine gun
ammunition cases from
the wreck of the Heinkel.
(J&C McCutcheon
Collection)

Post-War to 1966

It was due in no small part to the divide between the Allied countries and the Soviet Union that Turnhouse remained under military control after the war, although it did begin to share its facilities with non-military companies.

On 28 April 1946, the Midlothian Sector headquarters disbanded and control of the station headquarters was transferred to Fighter Command Holding Unit. During this month RAF Turnhouse was closed down section by section. All technical equipment and surplus serviceable and repairable equipment was classified and despatched to the appropriate maintenance units, as were the gas and decontamination stores. All barrack equipment not in use was centralised in the central MT hangar.

On 1 October, the station was taken over by Reserve Command and Flight Lieutenant J. A. Sowrey, DFC, the adjutant of 603 Squadron, became Acting Station Commander.

The first commercial services began in 1946 when British European (later British European Airways) scheduled the first flight between Edinburgh and London in a Junkers Ju-52. The ex-Luftwaffe aircraft formed part of the fleet, having been reconditioned for purpose by Short Brothers in Belfast and given civil registrations. The journey cost £8 for a single and £11 for a return ticket. The service was suspended during the winter months, leading to many complaints as this left no air link between the two capitals.

The Vickers Viscount, a medium-range turbo-prop airliner, took to the air in 1948, and by 1950 was being used for the Edinburgh–London service with BEA, which ran until 1971 when the Civil Aviation Authority (BAA) bought the airport.

On 12 May 1947, the Ministry of Civil Aviation took over air traffic control from the RAF, with Mr Ashburner as Senior Air Traffic Controller, although on Sundays the tower was handed back to RAF control, and Customs facilities were in place from 19 May.

No. 2603 (City of Edinburgh) Light Anti-aircraft Squadron was formed at RAF Turnhouse on 23 May.

The Edinburgh Festival was launched in 1947 as part of plans to improve morale right across the country in the early post-war years, the 'At Home' days and 'Battle of Britain Day' proving very popular with the public, to whom RAF Turnhouse was opened on 24 May for the restart of 'Empire Air Day'.

Although RAF Turnhouse did not officially open as a civil airport until 1 April 1949, 7,000 passengers were recorded to have used the airport in 1948. From 1949, Edinburgh University Air Squadron was in residence with de Havilland Chipmunks and Tiger Moths.

The long-serving No. 1968 AOP (Air Observation Post) Flight, a detachment of 666 (Scottish) RAuxAF Squadron, was at Turnhouse with Auster AOP.5/6s from 1 May until 10 March 1957.

During the 1950s, it was thought by many that sea planes were the way that flying was going to develop and the old seaplane base at Leith was reopened when Aquila Airways started a service from Southampton to Edinburgh and Glasgow using converted Short Sunderland Flying Boats. The venture was short-lived; suffering from very poor passenger loads against stiff competition from land-based airlines such as Dan Air, it ceased operations in 1958.

BEA started a Monday–Saturday return service operating from Northolt to Aberdeen, Kirkwall and Lerwick with their 'Pionair'-class Scottish Aviation 32-seat Douglas DC-3 conversions, following in the spring of 1952 with a service from Kirkwall to Aberdeen, Turnhouse and Manchester.

On 23 April 1951, work began on extending the 13/31 runway to 1.8 km to allow operation of the de Havilland Vampire FB.5 (603 Squadron began to receive these in May, having returned to Turnhouse from RAF Leuchars), and a Type T2 hangar was erected in 1952 to house the Vampires. The steel-welded frame, clad with galvanised corrugated-iron sheets, had a clear length of 239 feet, a span of 113 feet 6 inches and clear height of 25 feet, and had been dismantled and transported from its original site at RAF Turnberry.

On 22 April 1952, Aer Lingus operated the first scheduled international flights to Dublin using their DC-3s, the inaugural flight being flown by EI-ACE. It was only in January 1964 that the DC-3s on the route were replaced by the F.27 Fokker Friendship, although these too were later replaced by Vickers Viscounts to accommodate the growing patronage of the service.

The runway extension had been completed by the late summer, and Operational Readiness Platforms (ORPs) had also been provided

at each end of the runway; these would be used in later years as additional parking areas at busy times. The shorter 08/26 runway had also been used for additional parking of diverted flights and chartered aircraft.

BEA began a Birmingham–Turnhouse service on 1 April 1953 (with some flights routed via Manchester), and 23 April was the start of a Glasgow (Renfrew)–Edinburgh–Birmingham–Northolt service with DC-3s and Vickers Vikings. Northolt ceased to be the London terminus for flights on 30 October 1954, and flights were transferred to Heathrow.

During the Battle of Britain Open Day at Turnhouse in September 1953, a Royal Canadian Air Force (RCAF) North-American Sabre F86A set a record, being the first to break the sound barrier at an air display in Scotland.

In 1954, BEA started a service to Lerwick, operating three times a week, and a daily service from Aberdeen to Heathrow via Turnhouse using Pionairs; these were replaced by Vickers Viscount turbo-prop airliners in 1955, and the service operated until 1957.

In August, work started on a new passenger terminal with an apron, roadways and a car park on the north side of the airfield. The purpose-built building, designed by architect Robert Hogg Matthew, was sited approximately 440 yards beyond the main RAF entrance, replacing the old 1934 ex-RAF barrack blocks that had been used for passenger facilities, and cost £85,000.

The new building boasted a 2,000-square-foot concourse, check-in counters, baggage hall and customs facilities and offices, and was opened by Mr Harold Watkinson, MP, the Minister of Transport and Civil Aviation, on 12 April 1956.

In August 1956, Air Commodore Roger Leslie Topp, AFC, flew a Hawker Hunter F.4 (WT739/R) to set a new Edinburgh–London speed record, flying the 331.6 miles in 27 minutes 52.8 seconds. This record would stand until 1987.

On 9 March 1957, a Spitfire Mk LF.XVIE (RW393), which had been used in the film *The Battle of Britain* and carried the 603 Squadron RAuxAF markings of XT-A, became the static display gate guard at RAF Turnhouse. The following day, all twenty of the squadrons of the Royal Auxiliary Air Force were disbanded, including 603 Squadron, which, commanded by Squadron Leader M. E. Hobson, AFC, made a last fly-past over Edinburgh with a formation of seven Vampires and one Meteor.

On 1 April 1957, Southend-on-Sea-based James Barnaby, Thomas Keegan & Cyril Stevens, trading as BKS Air Transport Ltd, became

the first independent British airline to operate scheduled services to Ireland after the Second World War, operating twice-weekly flights to Belfast and on to Newcastle using DC-3s. From 23 May 1958, the Edinburgh part of the service was operated three times a week using Airspeed AS-57 Ambassadors (Elizabethan); the service was increased to daily flights during the summer months.

On 1 June 1958, Silver City, another independent British airline (which, during 1955, became the largest carrier of air freight in the country), started daily service to the Isle of Man using de Havilland Herons for five days and Bristol 170 Freighters on a Friday and Sunday. The Heron 1Bs were replaced by the DC-3 from the summer of 1960.

In 1960, The MoD transferred ownership of RAF Turnhouse to the Ministry of Aviation, demilitarising the airfield and allowing commercial services to be improved. The airport was temporarily closed in 1961 to allow the 13/31 runway to be strengthened to facilitate BEA operations of the Vickers Vanguard on the Heathrow–Turnhouse route, and between April and June, East Fortune (situated 23 miles to the east of Edinburgh) was used for all flights for the work to be carried out. During this period, it handled 2,640 aircraft movements and 96,000 passengers. The opportunity was also taken to transport the visual control room from the recently closed Blackbushe airport in Hampshire and erect it on top of the original wartime control tower at Turnhouse, and a new customs block was built at a cost of £49,000, added into an extension to the south-eastern section of the terminal.

Ferranti, which had produced marine radar equipment, gyro gunsights for fighters and one of the world's first IFF (Identification Friend or Foe) radar systems during the Second World War, had several aircraft based at Turnhouse and were focused on the development of airborne radar along with inertial navigation systems, which became an important product line for the company, subsequently supplying radar and systems to most of the UK's fast jet (Harrier, Phantom, Tornado) and helicopter fleets.

On 1 February 1961, Loganair was established as the air-taxi service for Logan Construction Company Ltd, and operated a single Piper Aztec (G-ASER) from Edinburgh to Dundee. Demand for scheduled services by the company was quickly realised and the network was expanded over the next few years to include the Scottish Highlands and the Orkney and Shetland Islands, the fleet growing accordingly.

One unusual visitor to East Fortune when it was used as Edinburgh airport was KLM DC-7F (PH-DSE), which arrived on 15 April 1961. The cargo was listed as 3,060 live mink but it does not say whether they

were collecting or delivering them. Other irregular and one-off flights during 1961 included a Lloyd International Douglas DC-4 Skymaster (G-ARLF), which operated a flight to Hong Kong on 21 August 1961, and two days later a Skyways Constellation (G-ALAK) arrived from Berlin.

British United Airways (BUA), which in January 1962 had merged with British Aviation Services, was granted a licence to operate a service to Gatwick (its new base).

In the spring of 1962, BEA replaced the Pionairs with Handley Page Heralds on their Scottish routes; these were subsequently replaced by Viscounts when the company made their Scottish operation 'All Viscount' (with the exception of their Glasgow-based de Havilland Heron, which in turn had replaced the 'Rapides' on their services to the Western Isles) in 1966–67. BEA also introduced a route from Renfrew to Edinburgh, Inverness, Wick and Kirkwall, which operated from Monday to Friday.

In 1963, arresting barriers were added to the overshoot ends of the 13/31 runway. Designed for halting high-speed jet aircraft such as the Buccaneer, the 200-foot-wide restrainers would lie flat until needed and could be raised instantly.

Following overturned objections from BEA to almost all of British Eagle's licence applications to operate a number of UK routes, British Eagle started a daily service from Turnhouse to Heathrow on 4 November using the Bristol Type 175 Britannia 'The Whispering Giant' (G-AOVT operating the inaugural flight). Despite steady increases in passenger loadings, and the service being increased to ten flights a week, an unfortunate downturn in its use meant that it was not returning sufficient revenue to cover costs. Subsequently, the service was withdrawn on 20 February 1965; the British Eagle airline was voluntarily liquidated on 8 November 1968 after the loss of its Caribbean charter licence.

During the Cold War period, RAF Turnhouse was also made the home for the headquarters of 24 ROC (Royal Observer Corps) Group in October 1964. This was where information from the ROC's monitoring posts of nuclear blast and fallout data from East Central Scotland and the Borders would have been received, analysed and distributed.

The facility was located to the right of the entrance of RAF Turnhouse and consisted of a two-storey bunker that was semi-sunken, with an administration block adjacent to it.

By 1964, passenger numbers had risen to 454,000, reflecting a steady and substantial increase over the last ten years; only 55,000 were recorded in 1954.

BKS restarted their Edinburgh–Belfast service using the Airspeed Ambassador and continued the route until 31 October 1968, when Cambrian Airways took it over in an exchange for the London–Belfast route. Cambrian Airways also operated rugby charters and training flights with Viscounts at Edinburgh as well as operating a Belfast–Turnhouse service from the late 1960s to the early 1970s.

In 1966, a separate body, known as the British Airports Authority (BAA), which was established by the passing of the Airport Authority Act 1965, took responsibility for three state-owned airports – Heathrow, Gatwick and Stansted. In the following few years, it would also acquire responsibility for Glasgow International, Edinburgh, Southampton and Aberdeen airports.

BUA started daily jet services from Gatwick to Glasgow, Edinburgh and Belfast on 4 January 1966 – the proving flight had been made on 13 December 1965 with a BAC One-Eleven 201AC (G-ASJI) – and thus became the first scheduled all-jet operator on UK domestic trunk routes.

In September 1966, Strathair, the trading name of Strathallan Air Services Ltd, started a twice-daily Dundee–Edinburgh–Prestwick–Edinburgh–Dundee service using a DC-3 (G-APPO) and a de Havilland Dove (G-ASDD). The Dundee–Edinburgh–Prestwick service was withdrawn after just six weeks due to lack of support, and in 1967 an Inverness–Dundee–Edinburgh service was operated.

In 1967, a relationship was developed between Loganair and the Scottish Ambulance Service, resulting in a contract for providing and maintaining a twenty-four-hour air ambulance service for Coll, Colonsay, Oronsay, Mull and Oban. The service started with a Piper Aztec (G-ASYB) but was replaced by a dedicated Britten-Norman Islander (G-ATWU), which continued until 2006 when the contract was tendered out for larger aircraft. The service continues today, operated by Gama Aviation.

From the early 1960s, the problems at Turnhouse with crosswinds had been realised, and in 1963, proposals for a new runway had been made. Despite being hailed in 1965 as being the fastest-growing airport in the UK, in one week in March 1967 alone, there were fifty-nine scheduled flights that had to be diverted or cancelled because of crosswinds. This accounted for over a quarter of all scheduled flights for that week.

The Minister of Aviation, Roy Jenkins, submitted on 8 March 1965 that the cost of a new runway (£2–3 million) could not be justified. The stance was echoed by Roy Mason, the Minister of State at the Board of Trade, who said that the facilities at Turnhouse were adequate and the

director of the Edinburgh Corporation, H. A. Brechin, stated that the expenses of construction and maintenance of a new runway could not be expected to be borne by Edinburgh ratepayers.

It was only after a visit to Turnhouse by Roy Jenkins in September 1965 that he was prepared to consider a new terminal (costed at £750,000) but would not look at a new runway for at least another ten years.

Air Travel had grown at such a rate that the passenger facilities were operating at ten times their design capacity by the end of the 1960s.

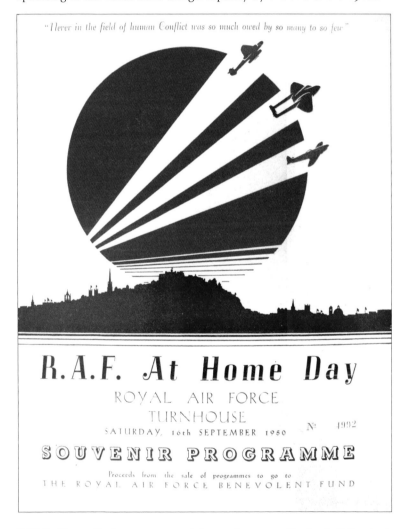

RAF 'At Home Day' programme, 16 September 1950. (Author's Collection)

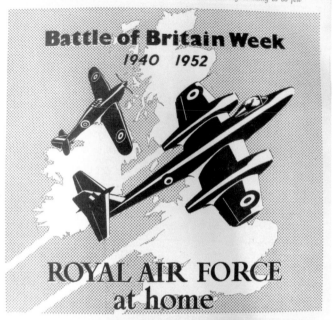

'Battle of Britain Week' programme, 20 September 1952. (Author's Collection)

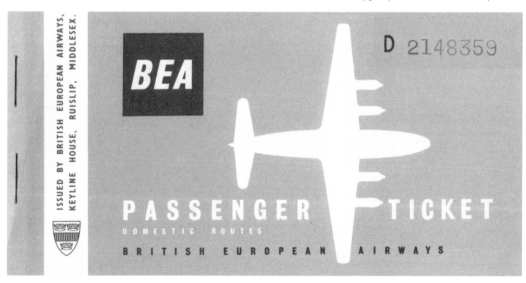

BEA ticket, 1959. (Author's Collection)

BEA TIMETABLE

Valid : 19 April–30 September 1959

British Isles

BRITISH EUROPEAN AIRWAYS

BEA timetable leaflet, 1959. (Author's Collection)

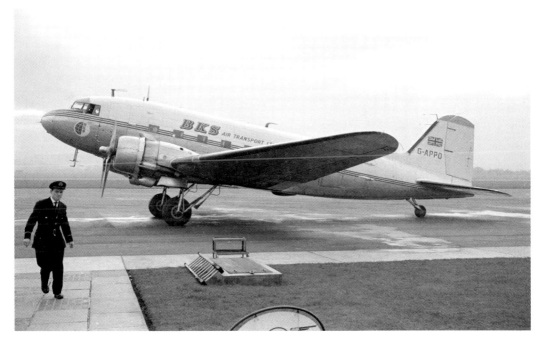

A loaded BKS Air Transport Ltd Douglas C-47B Dakota 4 (G-APPO) in 1960. (Colin Lourie)

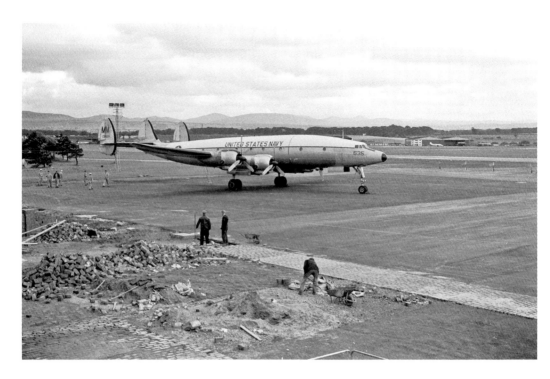

Lockheed C-121J Super Constellation 635 (FN-13635) from the Fleet Air Service Squadron (FASRON-107) as construction work begins airside in 1961. (Colin Lourie)

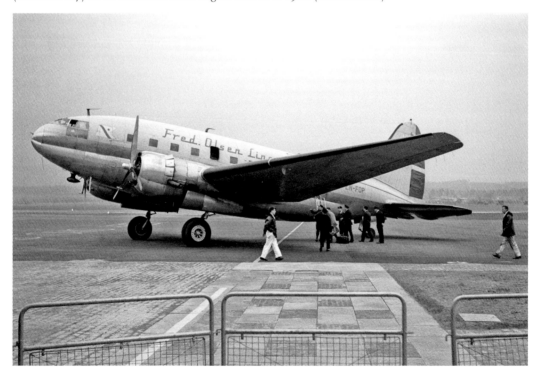

Fred Olsen Lines Curtis C-46 Commando (LN-FOP) in 1962. (Colin Lourie)

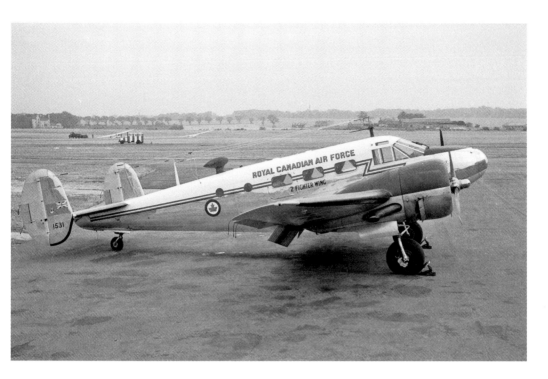

A Beech Expeditor 3TM (1531) of the Royal Canadian Air Force (2 Fighter Wing) in 1962. (Colin Lourie)

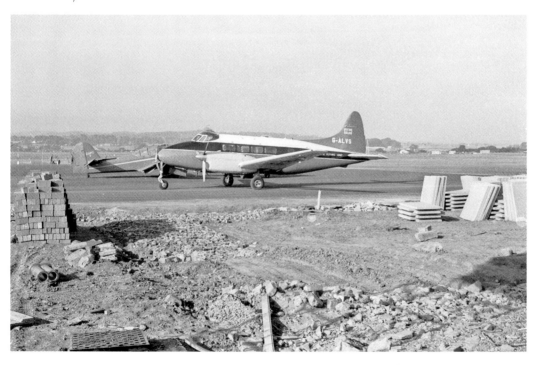

A 1949 de Havilland DH-104 Dove (G-ALVS) of the CAA Flying Unit in front of a 1948 Percival P.40 Prentice (G-APIT) in 1962. (Colin Lourie)

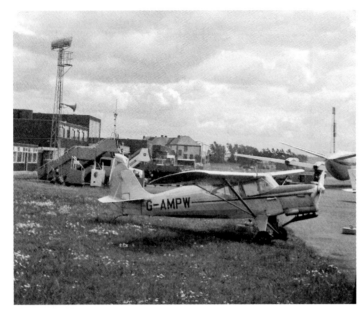

A 1952 Auster J-5B Autocar (G-AMPW) with a Vickers Vanguard in the background in November 1964. The aircraft was damaged beyond repair at Bonnybridge in April 1974. (Stephen Hall)

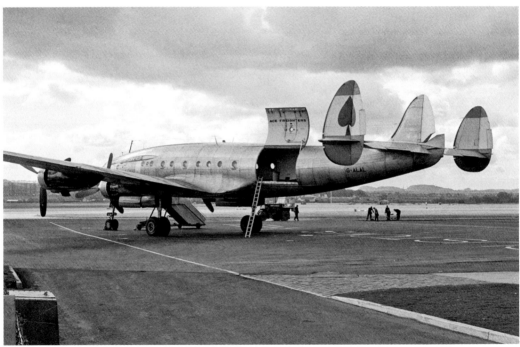

Lockheed L-749A Constellation (G-ALAL) of Ace Freighters awaiting loading in 1966. (Colin Lourie)

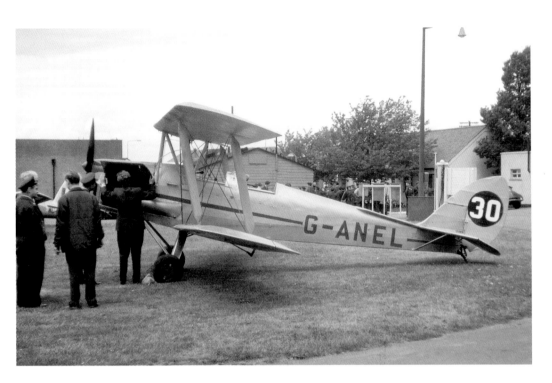

De Havilland DH.82A Tiger Moth (G-ANEL) at Edinburgh on 20 June 1968. (John Martindale)

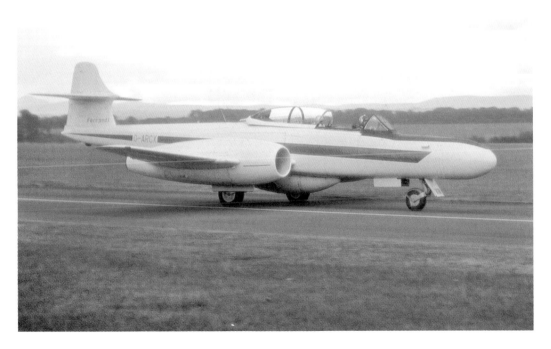

Gloster Meteor NF.14 (G-ARCX) Ferranti on 22 June 1968. (John Martindale)

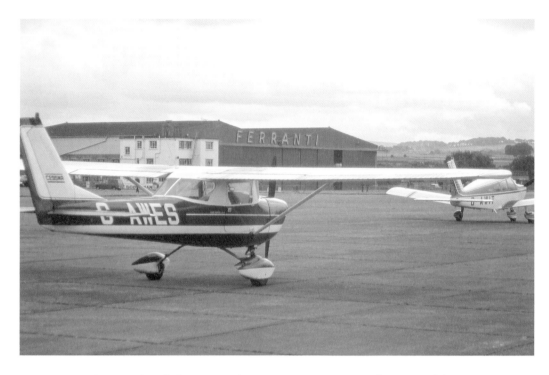

Cessna F.150H (G-AWES) with the Ferranti hangar on 28 June 1969. (John Martindale)

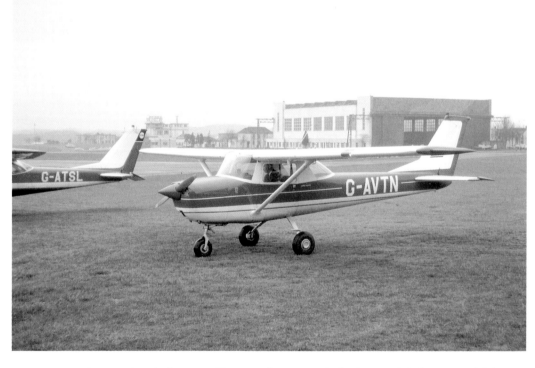

Cessna F.150H (G-AVTN) with the air traffic control tower in the background. (John Martindale)

34

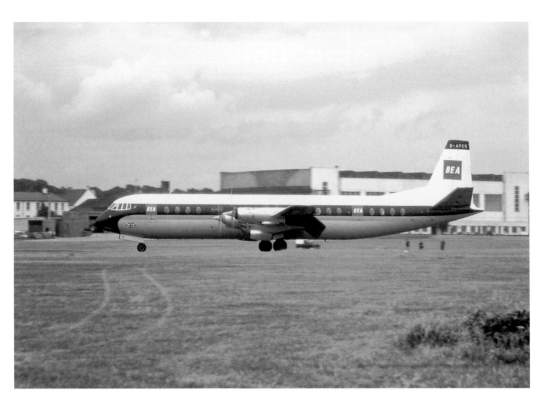

BEA Vickers Vanguard (G-APEB) leaving Edinburgh on 28 June 1969. (John Martindale)

1967–80

A newspaper report in February 1967 criticised the lack of radar at Turnhouse in which J. P. Mallieu (Minister of State at the Board of Trade) said that delays were due to crosswinds rather than the lack of radar. In addition, a long-running dispute continued between the Edinburgh Corporation and the Board of Trade, with the Board demanding that the Corporation should take over Turnhouse but the Corporation refusing to take over unless the Board first funded some of the new facilities that were required at the airport.

The main runway that had been laid during the war was fitted within the existing perimeter rather than the direction of the prevailing wind, and the subsidiary runway was too short, with a hill at one end, and diversions to Glasgow were embarrassingly frequent.

The stalemate continued and the subject was raised in the House of Commons on 30 January 1969 by Mr Anthony Stodart, MP for Edinburgh West, who said,

> It is deplorable and inexcusable that an airport at which passenger traffic has over the past 10 years increased by an average of 20 per cent per year, compared with an annual increase for all other United Kingdom airports of 14 per cent, an airport serving the city which is to house the Commonwealth Games in 1970, should have no adequate runway facilities, have no surveillance radar, and lack good terminal buildings.

Despite this situation, Turnhouse was to become the ninth busiest airport in the UK by 1969, handling 602,000 passengers.

From 16 January 1967, BEA began using de Havilland 106 Comet 4Bs twice daily for the Heathrow route while Viscounts were used on a daily service to Manchester and Birmingham. Towards the end of the year, British Midland Airways (known as Derby Airways until 1964)

began operating eight weekly flights to the new Castle Donington airport (now known as East Midlands airport) from 3 October.

On 4 August 1968, a Hawker Siddeley Trident II (G-AVFF) became the first recorded aircraft of its type to use Turnhouse. Another 'first' for the airport happened on 30 August when a Lufthansa Boeing 737-300 (D-ABEF) landed from Hamburg, departing later to Frankfurt.

Air Ulster, which operated charter flights as well as regular feeder services from Aldergrove to Prestwick and to several other mainland destinations, started a service to Londonderry (Northern Ireland) via Glasgow, but the venture had a short life span – the company folded two years later.

January 1969 heralded the start of the Channel Airways Scottish Flyer service from Southend airport in Essex. The twice-daily, multi-stop return service, with six four–five-minute-long intermediate stops (with the engines still running) including Luton, East Midlands, Leeds/Bradford, Teesside, Newcastle, Edinburgh and Aberdeen, was operated with modified, sixty-nine-seat Viscount 812s, which featured a large baggage compartment inside the aircraft's cabin. The route ran at a loss, however, and did not see the year out, being suspended on 28 November.

On 7 June, Iberia Airlines started a flight to Barcelona and Palma every Saturday throughout the summer using Sud Aviation SE-210 Caravelle jetliners to test out the Spanish holiday market. An overlooked problem was that Turnhouse officially closed at 2150 hours and Iberia were having to pay a 150 per cent surcharge on handling fees to keep the airport open until its return flight landed; they had also not been told that there was a strict leeway of only fifteen minutes for the return flight at 2330 hours. The Emergency Services Watch could not be extended beyond that time, and so any delay would mean either diverting the flight (to Glasgow) or stranding it until the following morning. After a flight was diverted on 16 August, the service was cancelled.

Air Anglia, which was formed at Norwich by the merger of three local air-taxi operators (Anglian Air Charter, Norfolk Airways and Rig Air), began a scheduled service to Aberdeen via Turnhouse on 7 December 1970 with a Britten-Norman BN-2A Islander. The company also started a twice-daily service from Turnhouse to Amsterdam on 1 April 1975.

On 1 April 1971, BAA took control of the airport (along with Aberdeen and Glasgow airports). At the time, the airport was handling much larger volumes of aircraft and passengers and the premises were now far too small.

Although the original main runway 13/31 (which is now the 12/30) served the airport well, the disadvantage of its alignment, the fact that the B9080 road had to be closed for landings and take offs, and the other two (minor) runways being very short and not able to be readily extended, meant that BAA started to expand the site by constructing a new runway to the west of the current airport boundary with a new terminal building on the eastern side of it to cater for the additional traffic (effectively doubling the size of the airport area), funding the enterprise themselves. The old terminal and hangars would be converted into a cargo centre.

The proposals were met with stiff opposition, mainly from local residents living in Barnton and Cramond, which would be under the flight path on the approach to the proposed runway 25, and started a planning enquiry that lasted until 3 February 1972, the publication of the findings not being published until March 1973.

One of the suggestions made was that the Edinburgh, Prestwick and Abbotsinch airports be closed and replaced by a Central Scotland airport to be built at Airth (between Glasgow and Edinburgh). The option was eventually rejected.

BEA formed a Scottish Airways Division (with a headquarters in Glasgow), which took on the financial responsibility of the airlines' flights from Glasgow to Belfast, as well as from Aberdeen and Inverness to Heathrow, improving the prospects of its loss-making Scottish lifeline routes. In the early 1970s, BEA also began phasing out first-class travel on its domestic services; they finally ended in February 1972. The airline also began to replace their Vanguards with Tridents on the Heathrow route from 1973.

On 1 April, British Caledonian, which had come into being in 1970, introduced simultaneous night-time departures using BAC One-Elevens from Gatwick, Glasgow and Edinburgh to Copenhagen via Newcastle, which resulted in an overall frequency increase to six daily round-trips on each route. Marketed under the trademark 'Moonjet', the company charged £5 for a one-way fare on this service.

In December 1972, the British Overseas Airways Corporation (BOAC), which, along with BEA, had been taken over earlier in the year by the British Airways Board under the chairmanship of Sir David Nicholson, and the British Airways feeder service to Prestwick (which encouraged the growing North Sea oil business to use BOAC's services across the Atlantic) was extended to Aberdeen from Edinburgh. It operated until March 1976, using Viscounts *Golly* and *Molly* (G-AMOG and G-AMON), which were both ex-BEA aircraft and were charted from Cambrian Airways, and the service was taken over by British Midland Airways.

In June 1973, work got under way on the redevelopment of the airport at a cost of £13 million. During the time it had taken for the proposals for the redevelopment to pass the planning stage and the long period before the subsequent publication of the findings and the work starting, the terminal was working at eight times greater than its design capacity with passenger numbers increasing (mainly from domestic scheduled flights) – despite the oil crisis of 1973 – and cargo and mail traffic increasing by 46 per cent in the same year.

This led to modifications being made; two offices were removed from the arrivals hall, the customs area was altered to create more space and motorised baggage belts were installed in the arrivals hall to speed up the throughput of passengers. Work on the new terminal did not start until March 1975.

Externally, set-down and pick-up facilities were improved by the rearrangement of the approach roads and forecourt. An overflow car park was also constructed to the north of the B9080.

The new runway 07/25 (which has since become 06/24) was 8,386 feet in length and had a full Category II status for lights and ILS (Instrument Landing System). It was also able to take all modern airliners including Concorde. This and the new taxiway were completed in time for operations to begin on 1 April 1976, but although a new fire station and motor transport unit had also been built and was operational, industrial action by firemen over operating hours delayed the use of the runway until 7 April (the unions felt that the BAA had gone back on their promise at the enquiry that, in return for permission to go ahead with the new runway and terminal, it would see the airport open twenty-four hours a day, thus bringing in more jobs. However, after permission was granted, the airport remained closed between midnight and 8.00 a.m.).

BA/BEA introduced a shuttle service on three of their Heathrow–Glasgow, Edinburgh and Belfast routes in April 1976. It proved to be a great success, with passenger numbers continuing to grow, and stand-by aircraft were used as dupes when the first aircraft was full. In the same month, Loganair (which had been under the ownership of the Royal Bank of Scotland since 1968) started a direct service to the Shetlands (Tingwall) using de Havilland DHC-6 Twin Otters.

The new terminal building, which covered an area of 146,000 square feet, had gates for ten aircraft and three air bridges designed to reduce the average distance between the terminal forecourt and the aircraft door to around 164 feet. It was officially opened by Her Majesty the Queen on 27 May 1977, and became operational two days later.

However, the airport was not being utilised to its full potential due to transatlantic flights still using Prestwick airport. Before the introduction of longer-range aircraft, Prestwick was the first point of call for aircraft to land and refuel after the transatlantic crossing, and the transfer of passengers to and from Edinburgh was carried out by BAA-operated coaches.

During Easter 1978, resurfacing work was started on the 07/25 runway and its parallel taxiways. The 13/31 runway remained operational, and while the £2-million refit was in progress the runway was only closed during the night to allow daytime operations. The work was finished by September.

1979–80 saw the biggest increase in the use of larger aircraft on charter flights. These included Laker Airways McDonnell Douglas DC-10s and British Airways Lockheed L1011 Tristars. Charter destinations from Edinburgh were operated by Altair, Aviaco, Braathens, Britannia Airways, Dan Air, Monarch, Norfly and Sterling, and included Italy (Milan and Rimini), Germany (Munich), Romania (Bucharest and Constanta), Spain (Alicante, Barcelona, Girona, Ibiza, Malaga, Palma and Tenerife) and Yugoslavia (Pula). By 1982, there were twenty-five airline operators using Edinburgh for the summer-season flights to twenty-one holiday destinations.

A new division of BAA called 'Scottish Airports' was formed at the acquisition of Southampton, Aberdeen and Glasgow airports, and later included Prestwick and Edinburgh.

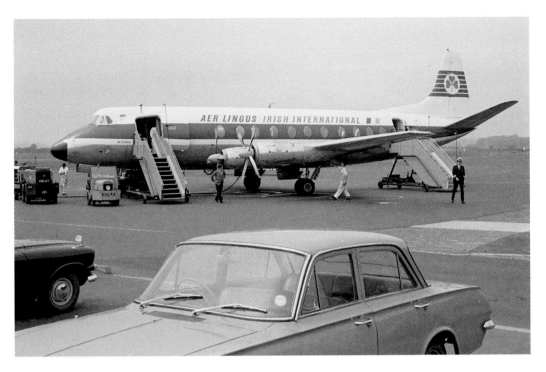

Aer Lingus Irish International Vickers Viscount 803 *St Cathal* in early 1967. (Colin Lourie)

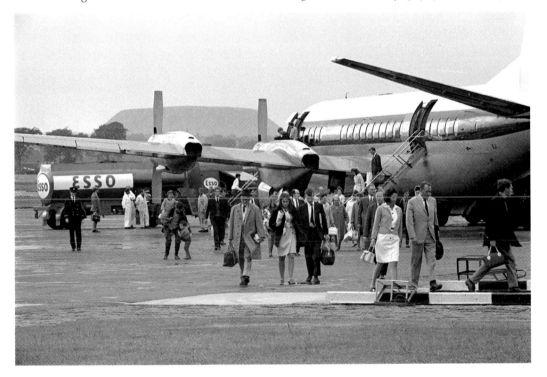

Passengers disembark a BEA Vickers Vanguard as the refuellers stand by in this photo taken in 1967. (Colin Lourie)

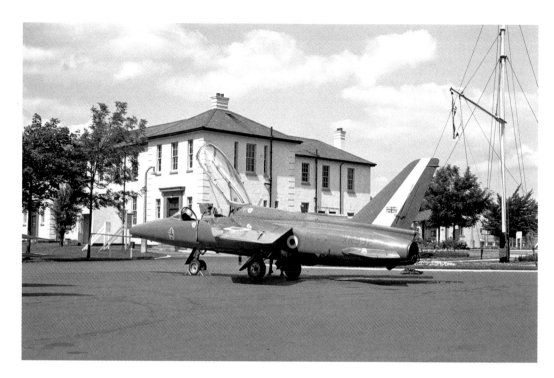

A Red Arrows CFS Gnat T1 (XR992) on display in 1967. (Colin Lourie)

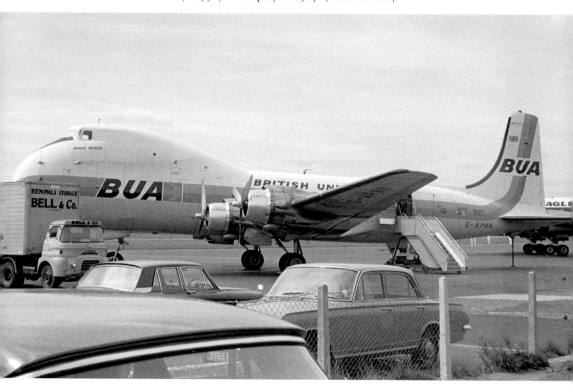

British United Airways ATL-98 Carvair (G-APNH) *Menai Bridge* in 1967. (Colin Lourie)

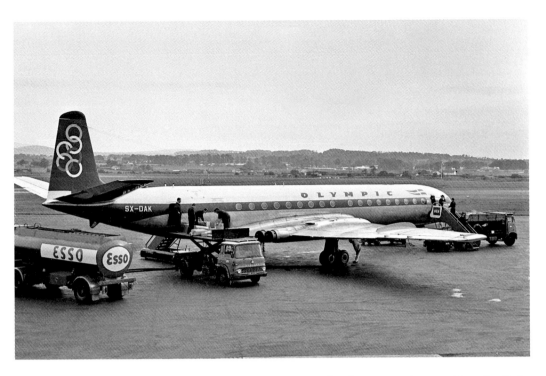

The flight crew disembarking Olympic Airways De Havilland Comet 4B (SX-DAK) in 1967. (Colin Lourie)

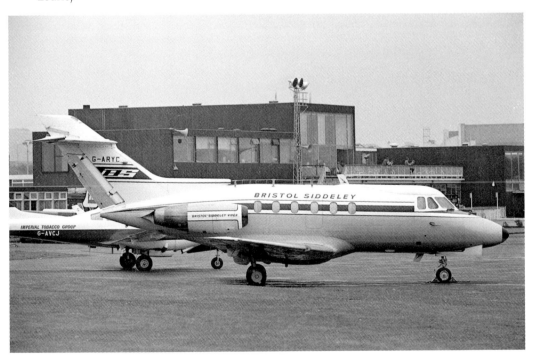

Bristol Siddeley HS-125 (G-ARYC); the first production standard series I model in 1967. Just behind is an Imperial Tobacco Group Beagle B.206 (G-AVCJ). (Colin Lourie)

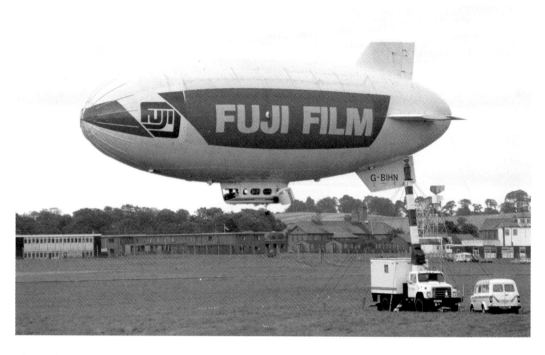

The airship (G-BIHN) in Fuji Film livery moored on the airfield. Some of the old RAF buildings can be seen in the background. (Colin Lourie)

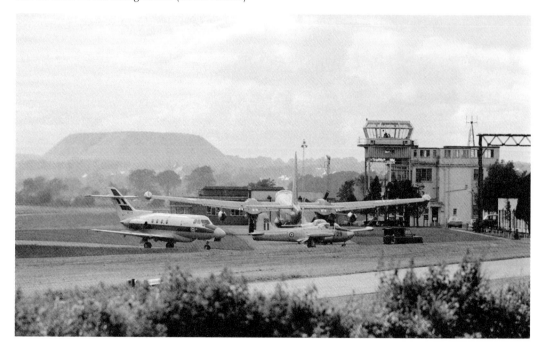

A Hawker Siddeley Dominie T1 (XS-735) and an RAF Hunting Jet Provost (XR-670) parked on the apron with the ex-Blackbushe control tower in the background in 1968. (Colin Lourie)

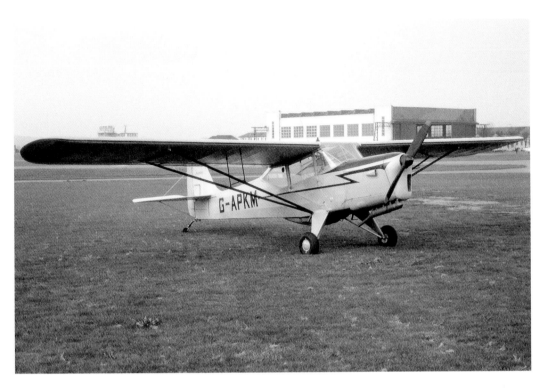

A 1958 Auster J-1N Alpha (G-APKN) on 27 April 1968. (John Martindale)

A Breguet Atlantique of the French Air Force at the Turnhouse Air Show on 22 June 1968. (Stephen Hall)

A Royal Navy Fairey Gannet (XL471) at the Turnhouse Air Show on 22 June 1968. (John Martindale)

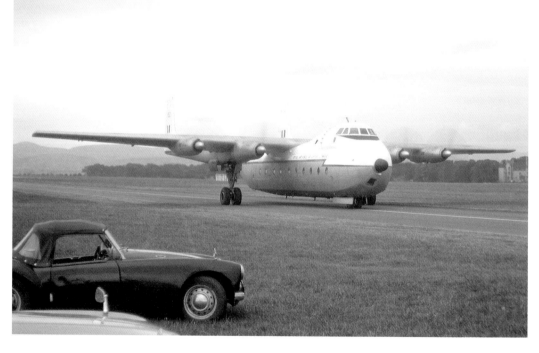

An Armstrong Whitworth Argosy C1 (XN-852) of the RAF Air Support Command at the Turnhouse Air Show on 22 June 1968. (John Martindale)

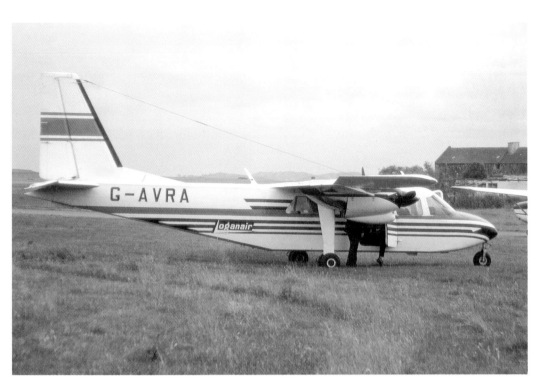

A Loganair Britten-Norman Islander (G-AVRA) on 28 June 1969. (John Martindale)

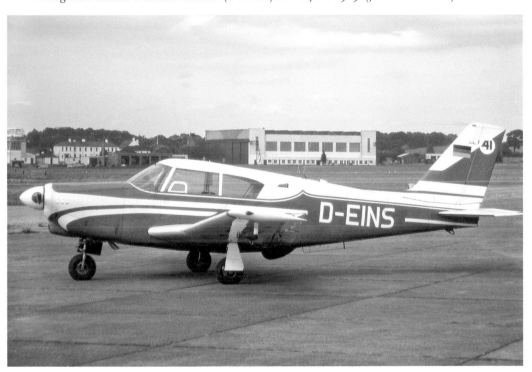

A Piper PA-24-250 Comanche (D-EINS) on 20 June 1970. (John Martindale)

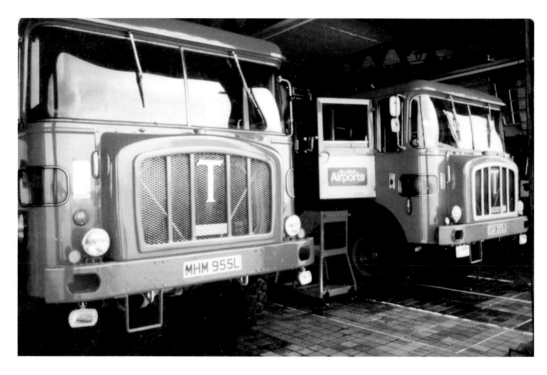

A 1973 Gloster Saro Meteor (MHM955L) airport fire/crash tender. (Colin Fraser)

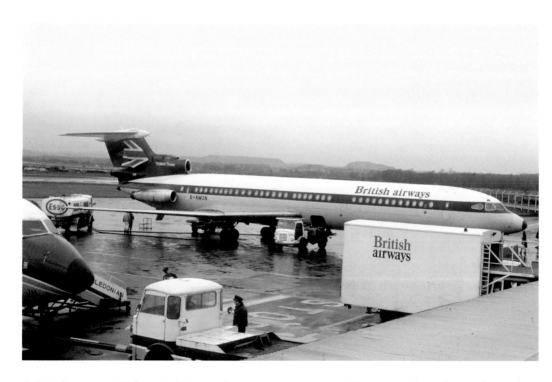

A British Airways Trident 3B (G-AWZN) on 10 January 1976, still in BEA colours but with BA titles. (Trevor Hall)

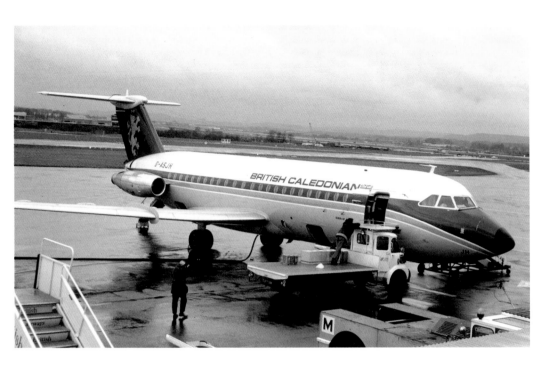

British Caledonian's BAC 1-11 201AC (G-ASJH) is seen from the old terrace at Edinburgh Airport on 10 January 1976. (Trevor Hall)

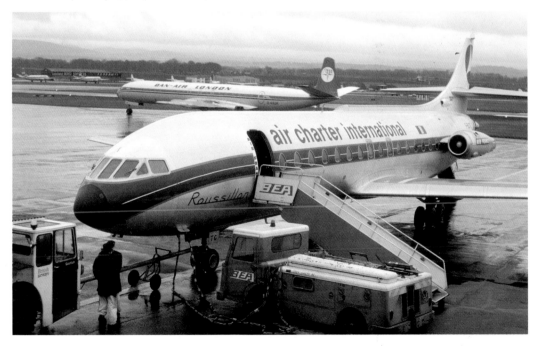

Air Charter International's Sud SE-210 Caravelle III (F-BJTG) at Edinburgh Airport on 10 January 1976. Two EAS Vanguards and three other Caravelles, plus a Herald, can be seen in the distance having already unloaded their passengers. The Dan-Air London Comet 4B (G-ARJK) was broken up in 1977 at Lasham. (Trevor Hall)

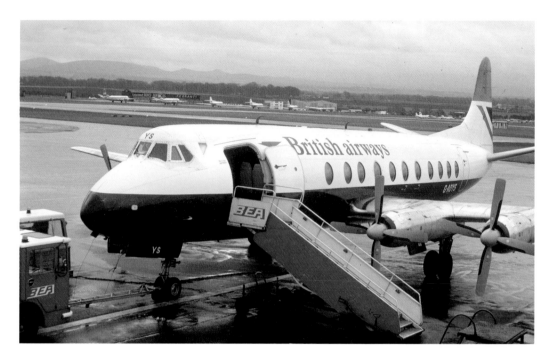

British Airway's Viscount 806 (G-AOYS) is seen at Edinburgh Airport on 10 January 1976. The aircraft in the background were present for a Scotland *v.* France rugby match. (Trevor Hall)

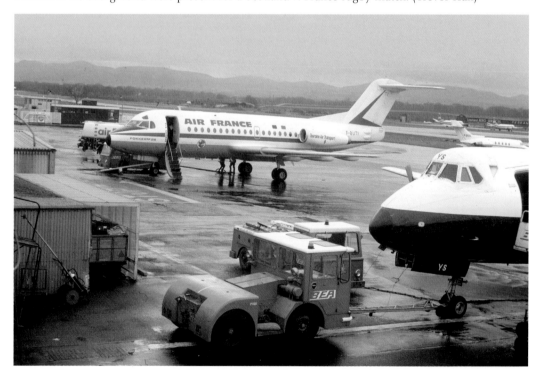

Air France/Touraine Air Transport's Fokker F-28 (F-BUTI) on the ramp at Edinburgh Airport on 10 January 1976. The BEA tractor in the foreground is P020 (registration HVB269). (Trevor Hall)

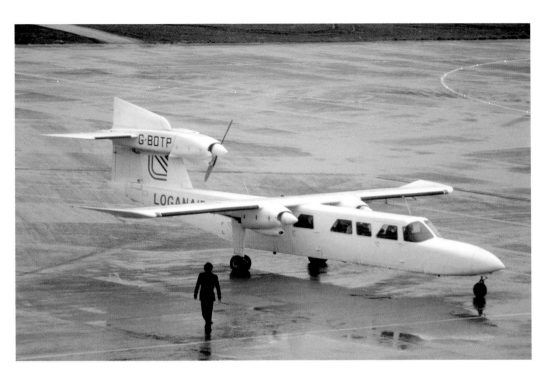

A Loganair Trislander (G-BDTP) is pictured at Edinburgh Airport on 4 February 1978. (Trevor Hall)

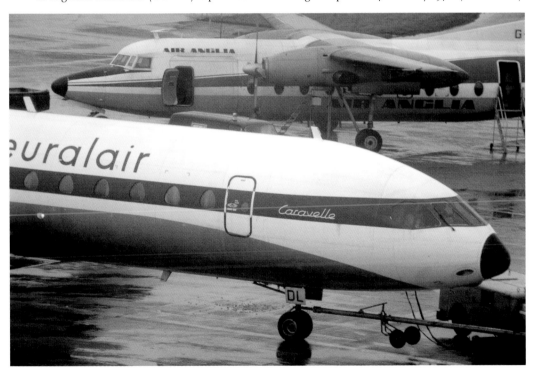

The forward part of Euralair Sud Aviation SE-210 Caravelle (F-BTDL) (136) is pictured with an Air Anglia Fokker F-27 (G-BFDS) in the background on 4 February 1978. (Trevor Hall)

Facing demolition: Looking northwards at the old Terminal Building from what was the apron in February 1980, long after it had ceased its original function, and until its end had been used as offices. (Colin Lourie)

1981–99

A slight decline in passenger numbers was experienced during the severe economic recession of the early 1980s, which impacted upon the tourist industry, and the only international services from Edinburgh were to Amsterdam, Dublin, Greece and Austria.

A new scheduled service to East Midlands was started by Inter City Airlines (previously known as Alidair), although this was a short-lived venture as the company went into receivership in 1983. Loganair's scheduled network was also growing, and added a new service to Kirkwall.

More significantly, cargo movements, which had been gradually declining in the recent years, were tackled by using smaller aircraft to accommodate size-respective loads, thus reducing the operating costs to a minimum, and this proved to be successful.

Further developments were carried out in the airport terminal, including improvements to gates 5 and 6 to facilitate the flow of passengers, and a duty-free shop.

On 23 March 1980, an Air France Concorde (F-BVFC) made her first visit to Edinburgh, attracting thousands of people to the airport to see one of the supersonic aircraft that were being operated daily between Heathrow and New York.

An aviation fuel terminal was installed adjacent to the main apron in December by British Petroleum in December 1980 (a further terminal was added by Esso in February 1981).

In December, the ILS was upgraded to Category III, being the most stringent system of its type for use in conditions of extreme low (or zero) visibility.

The Scottish commuter line Air Ecosse (a subsidiary of Fairflight Charters based at Biggin Hill) won a highly lucrative contract for the Royal Mail (Datapost), and operated direct flights with Embraer 110 Bandeirante turbo-props and Short 360-100s between Edinburgh,

Aberdeen, Luton, Liverpool and East Midlands. An extension to the airport's night-time closing time was granted to allow these flights only.

The subject of night-time flights was raised by the Tour Operators Study Group, who put pressure on the BAA and the Airport Consultative Committee to allow night-time flights, which would give the economy of the airport a much needed boost. The response took into consideration the effect on the environment and the hardship caused to the residents of Newbridge and Cramond and refused the application until the advent of quieter aircraft (which came into service by 1986).

With the recession over, expansion in all areas of the airport were carried out between 1983 and 1984. With renewed confidence, Air Anglia reintroduced their service to Paris in January 1984, and licence applications were submitted by Scottish Executive Airways for routes to Copenhagen, Brussels, Frankfurt and Paris. Inter City Airlines had gone into receivership in 1983, and Ecosse had been granted the licence to operate the East Midlands–Edinburgh–Aberdeen route.

British Airways introduced their 'Super Shuttle' service using Boeing 757 in August 1983, the year they launched their 'The World's Favourite Airline' campaign, with Boeing 737-236 aircraft being ordered as replacements for the Trident ahead of the 1986 noise deadline.

Passenger numbers at Edinburgh exceeded 1 million for the first time between 1983 and 1984.

In April 1984, BA launched a year-round Edinburgh–Aberdeen service in April and began a summer service to Jersey. Air UK launched a scheduled service to Stansted, which finally linked Edinburgh with all three major London airports.

Transatlantic flights began operating with a short-season service in June 1984 from Edinburgh to Toronto via Prestwick by Globespan (latterly FlyGlobespan) and the Canadian charter airline Worldways Canada using Douglas DC-8-63s. The service ended in September, but opened the way for regular transatlantic services into Edinburgh.

The financial year 1984/85 saw Edinburgh airport move into a trading profit of £900,000 (from a loss of £1.1 million the previous year) and cargo movements had steadily increased after a long period of decline. A fluctuation in passenger numbers was experienced during this period as Glasgow airport (which operated larger aircraft) offered lower fares to a number of their destinations.

On 8 July 1986, the Airports Act was passed, making major changes connected with the ownership and control of the airports of Great Britain. In the following year, BAA was floated on the stock market, and Edinburgh Airport Ltd (a wholly-owned subsidiary of BAA plc) took over ownership and operations at Edinburgh airport.

The resurfacing of the runway at Glasgow International airport (renamed after the BAA took ownership of Glasgow airport) trebled the night-time cargo traffic for Edinburgh in 1987.

In July 1987, during the celebration of the seventieth anniversary of its formation, two RAF F-4J Phantoms of 74 Squadron broke the speed record that had been held by Air Commodore Roger Leslie Topp, AFC, since 1956, making the record-breaking run from London to Edinburgh in 27 minutes, with the aircraft flying off the east coast at a maximum speed of 1,150 mph.

In May 1988, the eastern side of the apron by the main terminal was extended to become more flexible for parking aircraft, and was wide enough to accommodate two Boeing 737s. Inside the terminal, a new domestic check-in desk was added along with a new baggage-reclaim area. The year 1988/89 saw 2 million passengers using the airport.

One year later, in May 1989, Edinburgh finally became a twenty-four-hour airport. After a trial through the summer season, where tour operators increased the number of holiday destinations available, a significant increase was reflected in tour and domestic travel – and this was reflected by the increased operating profit of £6.7 million for 1989/1990.

On 24 March 1990, the 'Open Skies' policy (the deregulation of European air space – especially for commercial aviation) came into being following a decision by the Secretary of State for Transport. As a consequence of this relaxation, Prestwick was no longer the sole North Atlantic gateway airport, and both Glasgow and Edinburgh airports benefitted greatly. In the first year, Edinburgh had doubled its transatlantic passenger numbers.

In 1991, a two-year runway-resurfacing project was completed at a cost of £3.8 million, with the addition of an additional aircraft stand and further improvements made by extensions to the gate lounges.

The Cold War ended after the Soviet leader Mikhail Gorbachev introduced the Perestroika and Glasnost reforms, and the United Kingdom Warning and Monitoring Organisation (UKWMO) was wound up and disbanded in November 1992. The ROC HQ at Edinburgh was subsequently closed and some of the surface buildings were converted for use as air cargo stores, with the remainder being demolished to level the site, including the bunker. All that remains today is a large concrete slab on the bunker site.

In 1994, the original 1954 terminal building was demolished and the hangars converted into a cargo centre and flying club facilities, at a cost of £3.2 million.

The frontage of the terminal building was extended to accommodate larger numbers of passengers, the arrivals concourse was enlarged and a jet way was installed.

In March, Sabena World Airlines (of which Swissair had purchased a 49 per cent share), launched a dedicated twice-daily direct service from Brussels to Edinburgh using BAe 146-200s. A thrice-daily service from Luton to Edinburgh and Glasgow was also started by easyJet in November 1995, advertised as 'as cheap as a pair of jeans', with tickets costing £29 one-way.

In 1997, RAF Turnhouse was finally closed; the remaining buildings – the Mechanical Transport Shed being dismantled with the last Nissan huts, which were then the Edinburgh Flying Club's HQ – would be converted to storage for air cargo. A fibreglass replica of the Spitfire Gate Guardian was sited at the new entrance to Edinburgh airport and painted with the serial number L1067 (code XT-D). It was re-dedicated during a ceremony on 27 October 1996. The original Spitfire was moved and displayed at RAF Cosford, having been marked with the serial number TB675/4D-V.

Voted 'Best Regional Airport' by Executive Travel Magazine in 1997, growth had continued for the award-winning airport from the mid-nineties, but with low-cost airlines opening up new routes the facilities were once again becoming less than adequate in dealing with the increased traffic and passenger numbers.

May 1999 was the beginning of the first phase in a five-year project that would cost £100 million and would see a complete revamp of the terminal building. An extension included a new international arrivals hall, a new check-in hall with forty-six check-in desks and more retail outlets, such as WH Smith, Thornton's and the Sock Shop (which provide a significant income to the airport). Security had become the biggest priority in UK airports, and the loss that was felt by many was the closure of the spectators' terrace that ran along the (airside) frontage of the building.

As the summer of 1999 saw further increases in international services from Edinburgh, the 08/26 runway was closed for good on 11 July. General Aviation offices and additional car parking areas were part of the development of the 08 end.

The 5-acre 'cargo village', situated to the north of the airport and accessed from the Maybury Junction, became the key centre for freight forwarding and mail carrier companies such as TNT, Extrordinair Ltd, Northeast Cargo Ltd, DHL, Royal Mail and UPS.

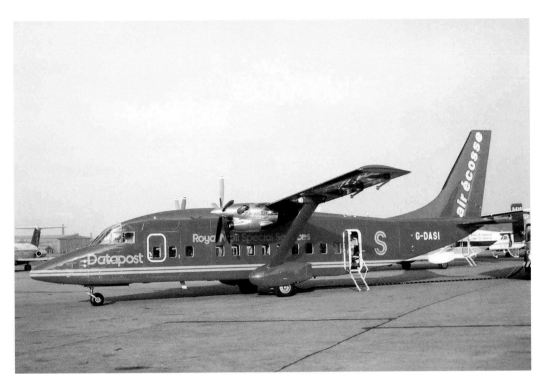

Air Ecosse-Datapost Short 360-100 (G-DASI) at Edinburgh on 16 April 1983. (Ken Fielding)

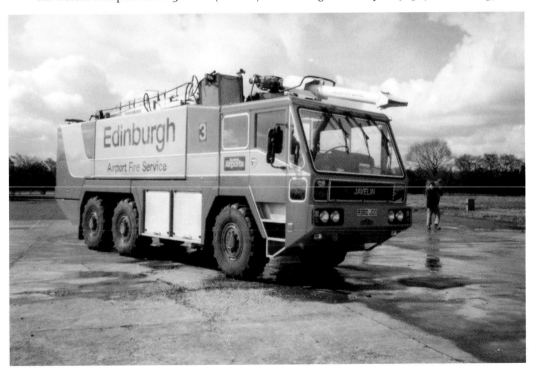

A Gloster Saro Javelin (A380JDD) airport fire/crash tender. (Colin Fraser)

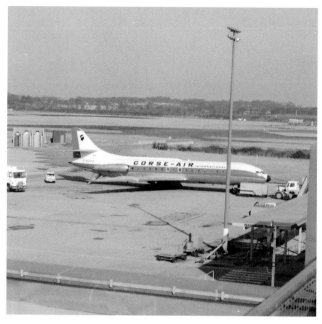

A Corse-Air International
Sud Aviation SE210 Caravelle
(F-BVPZ) in the early 1980s.
(James N. Saunders)

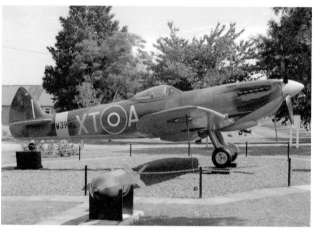

Supermarine Spitfire LFXVIe
(RW393 – XT-A) Gate Guard
at RAF Turnhouse, 10 August
1986. (Stephen Rendle)

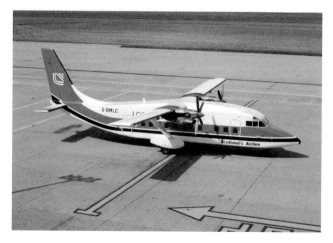

A Loganair Short 360-100
(G-BMLC) on 10 August 1986.
(Stephen Rendle)

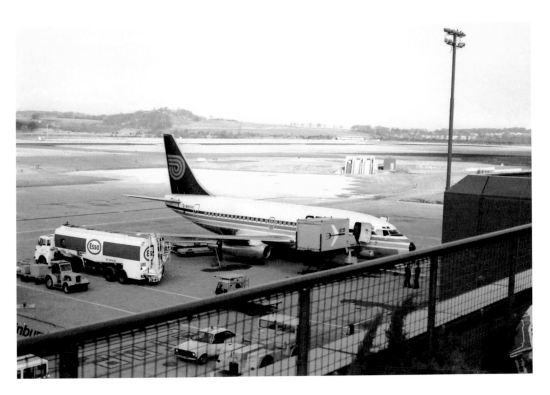

An Orion Airways Boeing 737-2T5 (G-BHVH). (James N. Saunders)

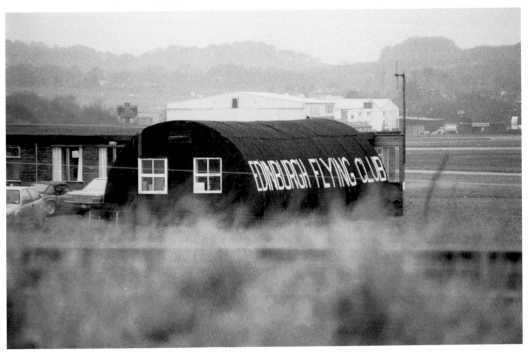

Edinburgh Flying Club's Nissen Hut in 1987. Access was via the RAF Main Gate and past the threshold of Runway 26 – 'the short runway'. (Colin Lourie)

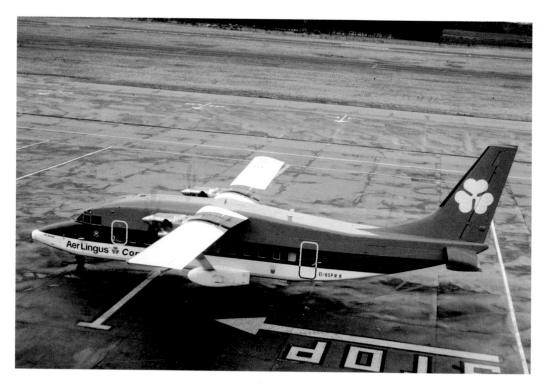

An Aer Lingus Commuters Short SD3-60 (EI-BSP) on 6 February 1988. (Trevor Hall)

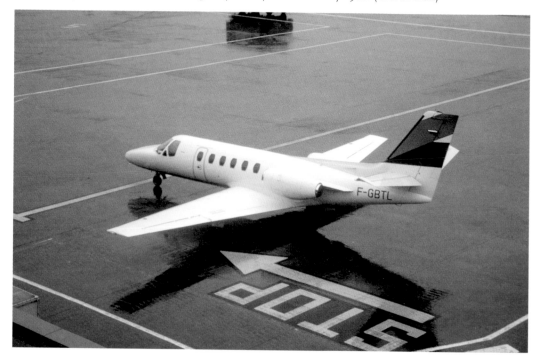

A French Citation 550 (F-GBTL) is pictured in front of the viewing terrace at Edinburgh Airport, on the day of the Scotland *v.* France rugby match on 17 February 1990. (Trevor Hall)

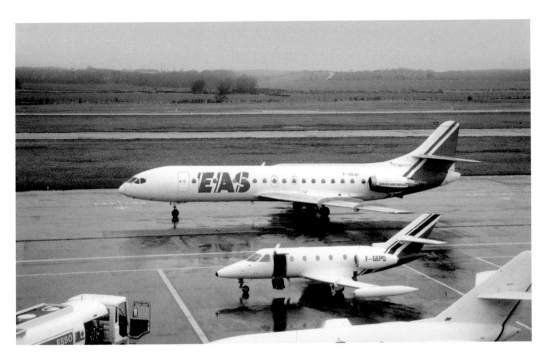

Taken from the long-departed viewing terrace, a Europe Aero Service Caravelle 10B3 (F-GDJU) is pictured arriving at Edinburgh Airport on 17 February 1990. Also in the picture is as SN-601 Corvette (F-GEPQ). (Trevor Hall)

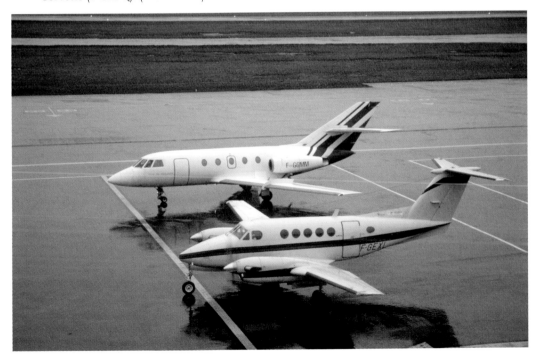

Two arrivals for the Scotland v. France rugby international on 17 February 1990 are a Beech Super King Air 200 (F-GEXL) and a Falcon 20 (F-GGMM). (Trevor Hall)

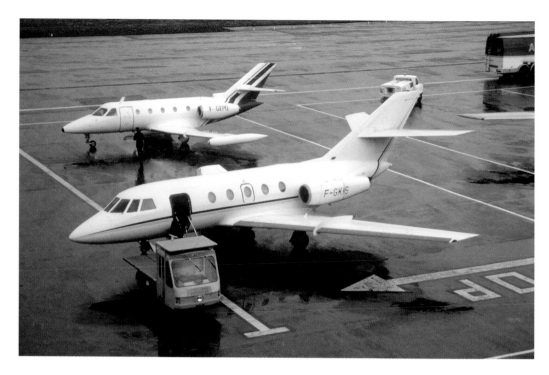

A Falcon 20 (F-GKIS) pictured with a Corvette (F-GEPQ) from the old viewing terrace on 17 February 1990. The BAA Edinburgh baggage wagon is registered XSF833R. (Trevor Hall)

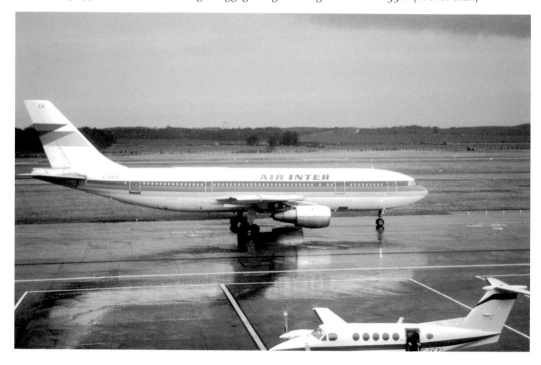

Air Inter's A300B2-1C (F-GBEA) on 17 February 1990 on a Scotland *v.* France related rugby charter. In the picture too is an Air Provence Beech Super King Air (F-GEXL). (Trevor Hall)

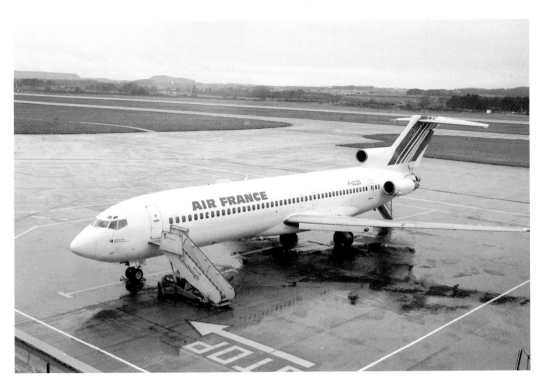

Air France Boeing 727-228 (F-GCDD) on 7 March 1992. (Trevor Hall)

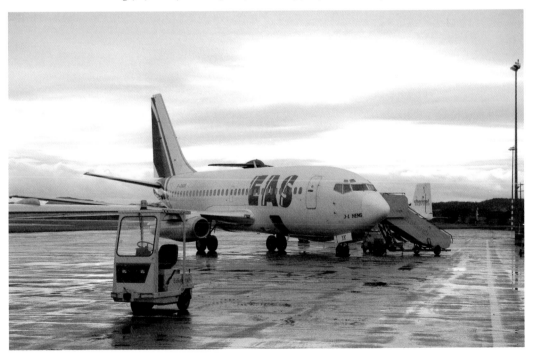

EAS Boeing 737-2A1 (F-GHXK) on a French rugby charter on 7 March 1992. (Trevor Hall)

2000–13

In May 2000, the Secretary of State for Scotland, Dr John Reid, MP, formally opened the first phase of the Edinburgh terminal redevelopment (Sarah Boyack, MSP, carried out a similar duty at the refurbished international arrivals facility in March 2001).

Reflecting a steady increase in growth, over 5.5 million passengers, and over 17,000 tonnes of cargo, passed through the airport in 2000 in 102,393 traffic movements.

During 2001, the terminal building underwent major renovations designed by Robert Matthew, and further expansions were proposed for the future with the hope that the scheme would double the current passenger capacity and put Edinburgh into sixth place behind Heathrow, Gatwick, Stansted, Manchester and Birmingham.

Edinburgh-based Globespan launched 'Flyglobespan', branded as a 'no-frills' service with the slogan 'Award-winning airline', and began offering flights to European destinations using Channel Express aircraft and crews. Within three years the airline had grown to offer fifteen destinations across Europe. However, the company that had become Scotland's biggest airline went into administration on 17 December 2009 with all scheduled flights being immediately cancelled. Over 3,400 people who had booked their package holidays directly through Flyglobespan, found themselves stranded overseas, and were eventually returned home with reduced-rate repatriation flights arranged by Ryanair and easyJet.

On Friday 24 October 2003, after twenty-seven years of service, Concorde flew into Edinburgh airport for the last time as part of a farewell visit. This would be its last landing and take off from Edinburgh; its next destination was a rendezvous with two other Concordes (one arriving from New York and the other having made a supersonic flight round the Bay of Biscay) for a final landing at Heathrow before being decommissioned.

In November, work began on the extension of the parallel taxiway to both ends of the main runway (and was completed in February 2004) and in December, the airport was open for the first time ever on Christmas Day.

In 2004, a Noise and Track Keeping system (NTK) was installed after agreement with Edinburgh City Council as part of the threshold limits being imposed on aircraft noise. The system allowed the monitoring of the route taken and noise made of every aircraft landing at and departing from Edinburgh airport.

May saw work start on a new state-of-the-art air traffic control tower situated on the main access road. Designed by Reid Architecture, its unique design would become a feature of the area's skyline.

On 2 June, Transaero Airlines began operating a weekly scheduled non-stop service with Boeing 737-700 aircraft (flying on Wednesdays) to Domodedovo International airport, Moscow, marking the first time ever that the two respective countries had been linked and boosting tourism and business opportunities.

In October, the new 187-foot-tall air traffic control tower was completed at a cost of £10 million and became operational at 2224 hours on 15 October (with an official opening by the Transport Minister, Alistair Darling, on 7 November). Its design combines the tower and base making it appear as one single form rather than the separate units of the base, stem and the visual control room often seen on other control towers around the world.

The top of the tower is fully glazed using sixteen panels of faceted glass, cambered to optimise the panoramic 360-degree views and clad with 9,216 zinc tiles (for their natural durability), and can be seen across Edinburgh and the Lothians.

In 2006, almost 8 million passengers had used the facilities at Edinburgh airport, which employed around 2,500 staff, with thirty-nine airlines operating there, making 112,000 air transport movements each year. Long-haul services to the USA from Edinburgh continued to thrive, with September passenger numbers doubling compared with the previous year.

In June, BAA, which operated 63 per cent of all air passengers entering or leaving the UK, succumbed to a takeover bid of £10.3 billion from the Spanish multinational company Ferrovial. A familiar name in the UK, Ferrovial also owned half of Bristol airport and the whole of Belfast airport. Through its UK subsidiary Amey, it also controls the thirty-year contract to upgrade and maintain the Jubilee, Northern and Piccadilly lines on the London Underground.

After a record summer, during which the airport handled over 4 million passengers, six gates on a new pier were added to the south-east of the terminal in September as part of a £300-million ten-year investment programme. The extension, called the 'South East Pier', was designed to cut overcrowding in the terminal during the busy morning rush hour (a further four gates would be added at the end of 2008). Two 196-foot moving travelators were also installed, and lifts were fitted for disabled travellers. The new extension was officially opened on 1 December 2006 by Scotland's First Minister, Jack McConnell.

In February 2007, the budget airline Jet2 took over the thrice-weekly Edinburgh—Prague route from Czech Airlines. Jet2 also increased the frequency of its flights to Murcia, Spain.

On 26 March, BMI started flights to Zurich, having expanded its fleet with four new Embraer 145 aircraft, and in May easyJet expanded its network with a new route to Dortmund, Germany.

Although May was the thirtieth anniversary of the airport, it was also the month that brought in new security measures for passengers having liquids in carry-on luggage, testing drinks, medicines and toiletries for hazardous chemicals through screening in the wake of the uncovering by British authorities on 10 August 2006 of a terror plot aimed at detonating liquid explosives on flights originating from the United Kingdom, Canada and the America.

On 9 August, Edinburgh airport overtook Glasgow as Scotland's busiest airport following a continued rise in passengers, while Glasgow experienced a dip caused by the terrorist attack in June.

A milestone figure of 9 million passengers were recorded at Edinburgh airport for the twelve months to November 2007 (exceeding Glasgow numbers by 300,000); the business and leisure services, many of which were supported by Scottish Government subsidies, reported record bookings.

For the first time since 1991, work began on the complete resurfacing of the main runway on 30 March with work being carried out between 2300 hours and 0545 hours (with flights diverted on to the secondary runway). The £16-million project, which was won by Infrastructure specialist Morgan Est plc, is expected to prolong the life of the runway for a further fifteen years as part of BAA's plans to invest £250 million on the airport over the next decade and was completed on budget and ahead of schedule at the end of November. Morgan Est's paving team laid around 25,000 tonnes of asphalt and replaced 1,000 runway lights.

On 2 May, Delta Air Lines responded to demand and at the same time claimed a 'first' by starting a year-round direct flight service to

JFK airport, New York. The service was operated by a Boeing 757-200 ETOPS (Extended-range Twin-engine Operational Performance Standards) aircraft incorporating 158 economy seats and up to 16 seats in their 'BusinessElite' class, with a flying time of 7 hours 57 minutes.

In June, Flyglobespan began a weekly direct service to Dubrovnik, complementing their service to Pula for holidays in Croatia.

In August, a report by the Competition Commission recommended that BAA should have to sell either Glasgow or Edinburgh airports along with two of its three flagship airports in the south-east – Heathrow, Gatwick and Stansted. Publishing the preliminary findings of its inquiry into BAA's control of the UK's largest airports, the Commission said BAA's current ownership structure was having 'adverse consequences' for passengers and airlines. It said many of the problems of recent years were due to the 'common ownership'.

In December, work began on a new departure lounge that would double the size of the existing facility, despite BAA being warned in August that it may have to be sold off. The work (which was completed on 20 November) was part of a programme of improvements to include a major expansion to the immigration hall, upgrades to the taxiways and the expansion of existing aircraft stands in order to compete effectively with the airports of Europe.

In February 2009, a five-year plan, including a £40 million revamp of the terminal, was revealed as the first phase in a £100-million investment. The 5,000-square-metre development would include shops, bars and two new restaurants to cater for an anticipated 13 million passengers by 2013.

Ryanair opened ten new routes in early April to serve Spain, Italy, Denmark, France, Germany, Greece, Malta and Croatia, with a further route flying twice weekly to Haugesund, Norway, in July, and eight new routes were added to their winter schedule, bringing the number of routes operated by Ryanair from Edinburgh to twenty-six.

The success trend continued for Ryanair in 2010, operating new routes to Morocco, Paris and Portugal, and Jet2, which operated a summer service to Majorca and increased the frequency of their flights to Ibiza. On 1 March, a new regional airline operator began scheduled flights from Oxford to Edinburgh offering VIP treatment on their eighteen-seat BAe Jetstream 31 aircraft.

Ryanair's continued expansion of operations from Edinburgh helped in no small way to securing the airport's placement as the fifth-busiest UK airport.

By the end of the summer, BAA announced that Edinburgh had its best-ever figures for September, recording 873,200 passengers.

In 2011, Edinburgh airport processed over 9.3 million passengers. The busiest domestic routes were to Heathrow, Gatwick, Stansted and London City airports, and Amsterdam topped the busiest international destination list followed by Paris Charles de Gaulle and Newark (New Jersey). In February, the airport was named by Airports Council International as one of the five best airports for customer service and facilities in Europe.

It was announced by BAA on 19 October 2011 that Edinburgh airport would be sold following an order by the Competition Commission that it must dispose of one of its largest Scottish hubs. Edinburgh was chosen over Glasgow in light of its recent success in the hope that it would be more attractive to bidders; a sale prospectus would be created by the city council, and it was made known that potential bidders would have to find the money to improve the roads leading to the terminal.

Arcus European Infrastructure Fund, Global Infrastructure Partners (GIP), JP Morgan Asset Management and the Private Equity firm 3i were the top contenders for the purchase of the airport. By December the airport was rated the second from top in Europe (out of forty-seven other contenders) in an independent survey by STV.

After an extension of the deadline for its sale, it was announced in April 2012 that GIP, the owners of Gatwick and London City airports, beat off the competition with a bid of £807.2 million, which was considerably more than anticipated, and the company took over ownership of Edinburgh airport on 1 June, appointing Gordon Dewar, the former Managing Director of Edinburgh airport, as Executive Officer.

On 12 June, the airport won the ACI Europe Best Airport Award as Best European Airport, in terms of both passengers and airlines.

In July, air traffic controllers were provided with the precise surveillance needed for the separation of arriving and departing flights when the Saab Sensis WAM (Wide Area Multilateration) radar system was installed (the first of its type in the UK). The WAM system uses multiple low-maintenance, non-rotating sensors to triangulate an aircraft's location based on transponder signals, increasing the safety, capacity and efficiency of airspace in any weather conditions.

A Rosenbauer 'Panther', a £500,000 state-of-the-art fire engine custom-made for the airport, was delivered in July, replacing an obsolete vehicle.

On 26 November, overhead power cables erected between the tram depot in Gogar Castle Road and the airport (around 1.86 miles) became electrified to allow testing of the network for its safety and reliability. The project is expected to be completed by summer 2014.

In the wake of the sale of the airport by BAA, a drop in international traffic presented a challenge for its new owners, but route-development plans by the new owners GIP were in place to return the airport to growth, and on 4 December 2012, Ryanair and Edinburgh agreed a deal for six new routes – Bologna, Beziers, Cagliari, Corfu, Katowice and Santander – to be operated from the summer of 2013, and an increase of frequencies of five other routes.

On 7 February 2013, Edinburgh welcomed the decision by easyJet to operate six direct flights a week to London Southend airport with the service starting on 2 May, which would finally connect Edinburgh to all six London airports.

On 8 April, Virgin Atlantic, following its take-over of bmi in 2012, began a competitive service from Edinburgh to Heathrow under the brand of 'Little Red' (using Aer Lingus aircraft and crew) as the major part of its venture into domestic flights.

Looking towards the summer of 2013, confidence is high with the positive impact of deals with easyJet, Virgin Atlantic and Ryanair for new routes across the UK, Europe, North America and Canada.

The Cat Stane, airside at Edinburgh airport, marks the location of a fifth- or sixth-century Christian burial site, which during excavation in the 1860s revealed the remains of fifty-one individuals. (Calum McRoberts)

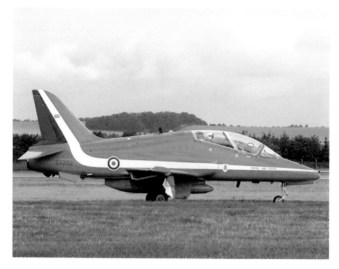

British Aerospace Hawk T1W (XX292) ready to depart for a display in 2003. (Joe Curry)

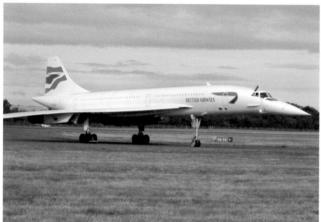

British Airways Concorde (G-BOAE) taxies to the terminal on its final visit to Edinburgh before it retired from service on 24 October 2003. Crew for the flight were captains Les Brodie and Andy Bailie who flew the Saltire from the cockpit window as they taxied past the huge crowd of spectators. (Andy Eccles)

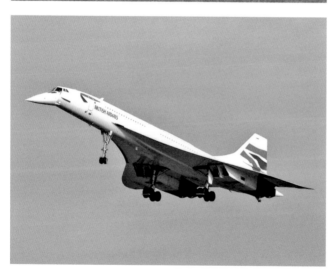

British Airways Aerospatiale-BAC Concorde 102 (G-BOAE) Farewell Flight, 2003. (Joe Curry)

An Italian Air Force Lockheed Martin C-130J Hercules (L-382) landing at Edinburgh in 2004. (Joe Curry)

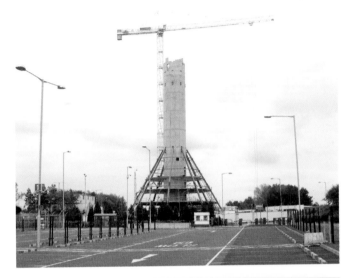

The new airport control tower under construction around the central column in October 2004. (Colin Lourie)

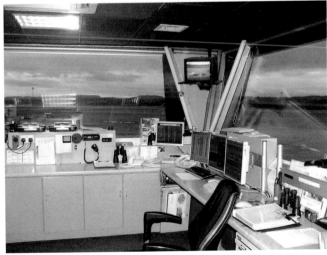

The airport operations room in 2005. (Joe Curry)

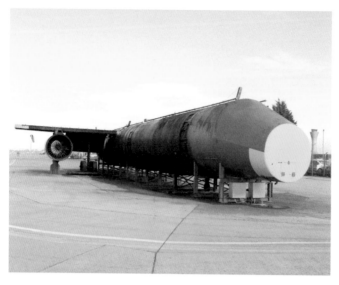

A 'dummy' plane (complete with steel seats inside) at Edinburgh airport is used for live fire-fighting training. (Calum McRoberts)

A fire training car park scene set up behind the perimeter fence in 2005. (Joe Curry)

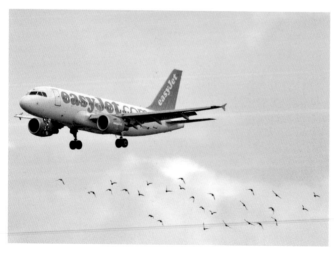

Birds are always the natural hazard at airports. (Joe Curry)

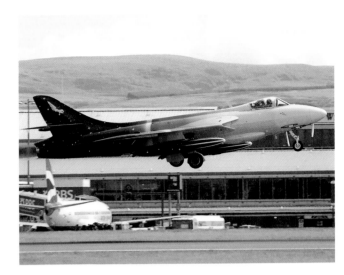

Hunter Flying Club Hawker Hunter (G-PSST) on 26 October 2007. (Scott Wright)

A Lockheed C-130K Hercules C3P (XV305) carrying the RAF Falcons parachute team on 26 October 2007. (Scott Wright)

A Polish Air Force Tupolev Tu-154M (90A837) (101) on 30 October 2007. This aircraft crashed on 10 April 2010 killing the Polish President Lech Kaczynski and several members of the Polish establishment. (Scott Wright)

73

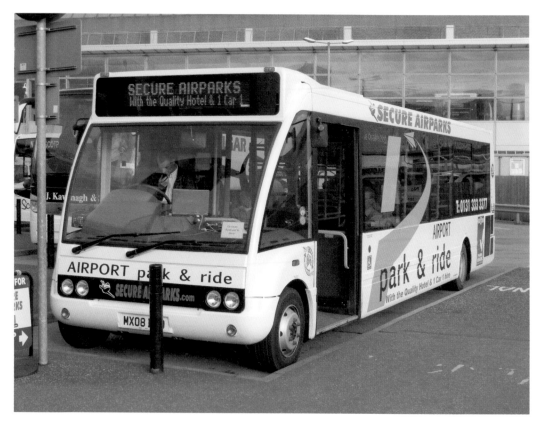

Secure Airparks of Edinburgh Airport's Optare Solo (MX07BBV) is seen on Park & Ride duty at the airport on 20 September 2008. (Trevor Hall)

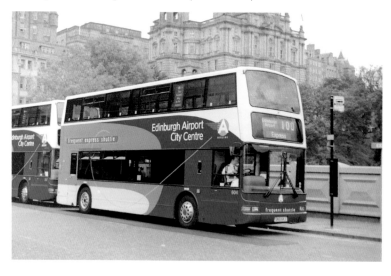

A Plaxton-bodied Dennis Trident 'Prestige' (SN51AXJ) Airlink 100 Shuttle Bus. (Author's Collection)

This Gloster Meteor NF.14 (G-ARCX) was used as a test-bed for radar development by Ferranti. It is pictured in the Scottish Museum of Flight on 30 October 2009. (Trevor Hall)

A Simon Meteor Mark 2 Light Foam Tender (G806CFH), seen here in the Scottish Museum of Flight on 30 October 2009, was used at Edinburgh Airport. (Trevor Hall)

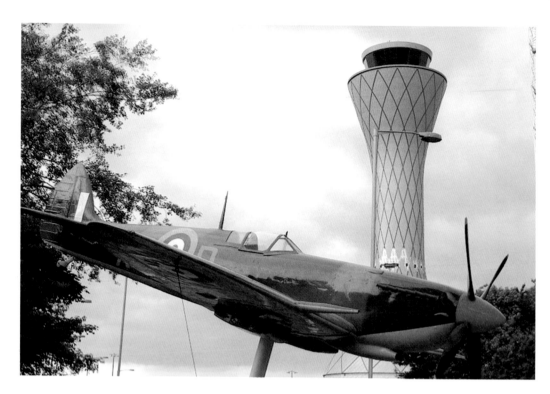

Edinburgh Airport control tower and gate guard, a replica Spitfire (L1067/XT-D) on 12 December 2009. (Ronnie Bell)

British Midland Airbus A319-131 (G-DBCB) taxis to the terminal after landing on 28 February 2009. (Brian Donovan)

Airbus A380-800 (F-WWOW) carrying the 'Greener, Cleaner, Quieter' tag levels out after performing an 'approach and go' manoeuvre on 5 September 2009. (Brian Donovan)

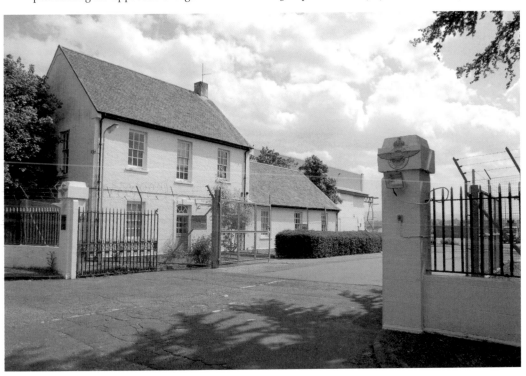

The former station headquarters and entrance to RAF Turnhouse in May 2010. (Matt Curtis)

The former station headquarters at RAF Turnhouse (1 April 1918–1 April 1996) in May 2010. (Matt Curtis)

Former buildings at RAF Turnhouse (1 April 1918–1 April 1996) in May 2010. (Matt Curtis)

Former buildings at RAF Turnhouse (1 April 1918–1 April 1996) in May 2010. (Matt Curtis)

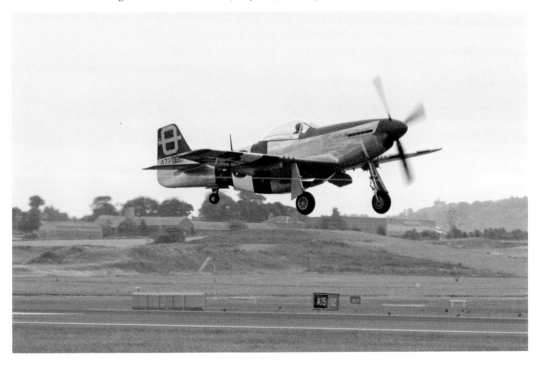

North American P-51D Mustang G-SIJJ/472035 departs Edinburgh Airport en route to its display at the East Fortune Airshow on 24 June 2010. (Brian Donovan)

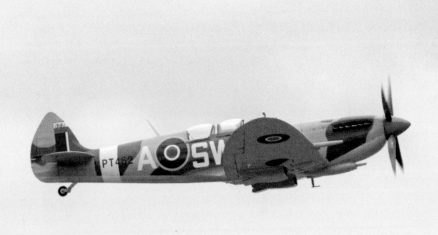

Vickers Supermarine Spitfire MK.T IX (G-CTIX/PT462) leaves for a display at the East Fortune Airshow on 24 June 2010. (Brian Donovan)

A Douglas Skyraider AD4-NA G-RADR/26922 leaves Edinburgh for a show at East Fortune on 24 June 2010. (Brian Donovan)

Above and below: The bmi lounge at Edinburgh Airport on 26 January 2011. (Micko)

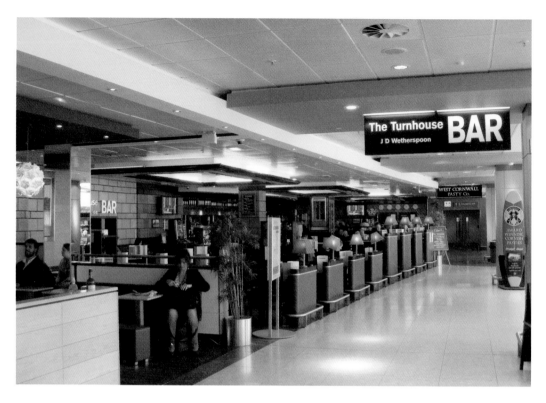

Turnhouse was the old name for what is now Edinburgh Airport, so it was a natural title for J. D. Wetherspoon's landside bar in the terminal, seen here on 9 June 2011. (Trevor Hall)

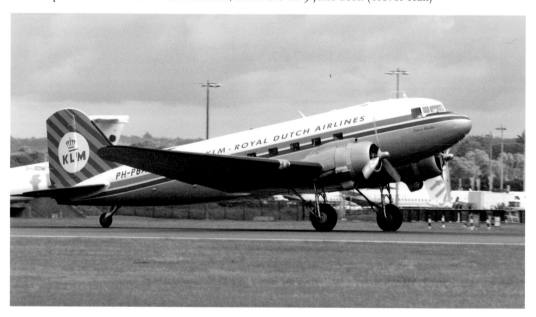

Celebrating sixty-five years of KLM flying to Scotland, a Royal Dutch Airlines DC3 (PH-PBA) *Princes Amalia* in historic KLM colours, flew from Lelystad in the Netherlands to Glasgow and then on to Edinburgh (as seen here) on 17 August 2011. (Brian Donovan)

The Fed-Ex Boeing 777-FS2 (N892FD) carrying Giant Pandas Tian Tian and Yang Guang from Chengdu, China, to their new home at Edinburgh Zoo passes by the passenger terminal on 4 December 2011. (Brian Donovan)

Another view of the FedEx Express Boeing 777-FS2 arriving at Edinburgh after its nine-hour flight on 4 December 2011. (Derek McDougall)

Scaffolding around the new Air Traffic Control tower at EDI. (Lewis Martin)

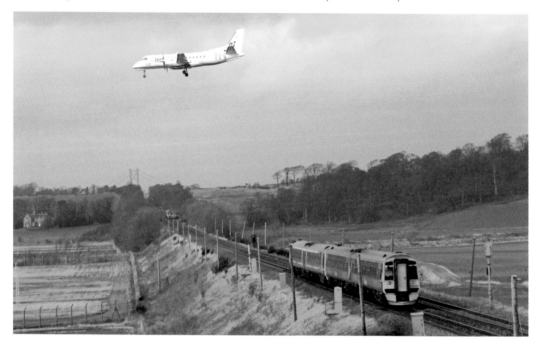

A flybe Saab 340 (G-LGNM) crosses the threshold at Edinburgh while daily commuters travel on the Scotrail service heading north approaching the Forth Bridge on 1 March 2012. (Graeme Gibson)

A Malmö Aviation BAe RJ85 (SE-DJO) and an easyJet Airbus A320-214 (G-EZTX) on 15 April 2012. (Robert McCulloch)

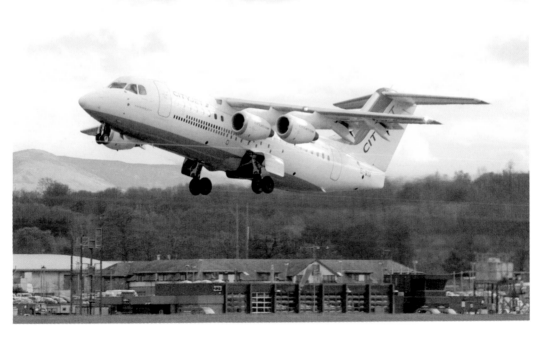

A CityJet BAe Avro RJ85 (EI-WXA) departing Edinburgh on 15 April 2012. (Robert McCulloch)

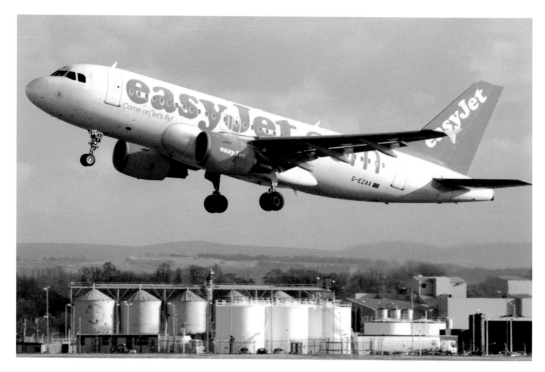

An easyJet Airbus A319-111 (G-EZAX) departing Edinburgh on 18 April 2012. (Robert McCulloch)

British Airways CityFlyer Embraer 190LR (G-LCYM) taxies at Edinburgh on 18 April 2012. (Robert McCulloch)

Approaching the terminal by road on 4 June 2012. (Viviane Bruns)

A British Airways A320 and the main terminal building at Edinburgh Airport on 26 May 2012. (Steven Campbell)

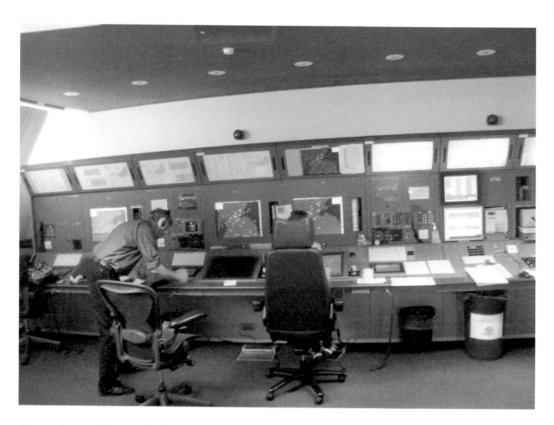

Approach controllers at Edinburgh Airport on 26 May 2012. (Steven Campbell)

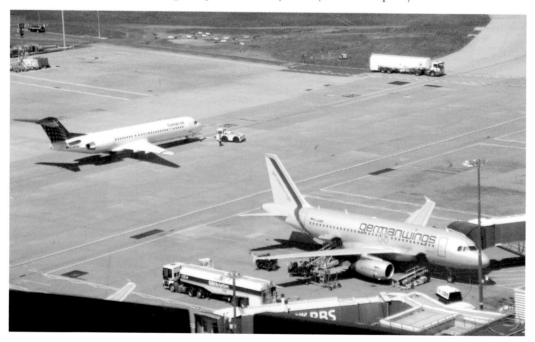

Germanwings and Contact Air at Edinburgh Airport on 26 May 2012. (Steven Campbell)

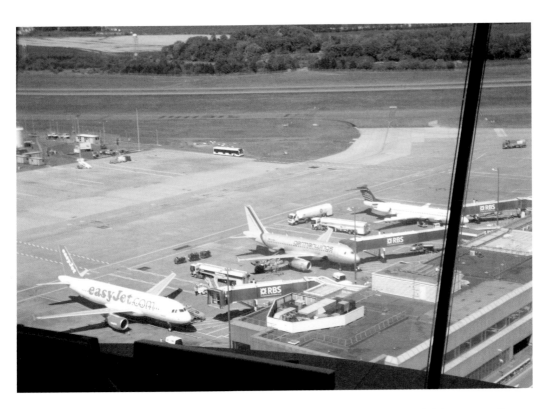

easyJet, Germanwings and Contact Air at Edinburgh Airport on 26 May 2012. (Steven Campbell).

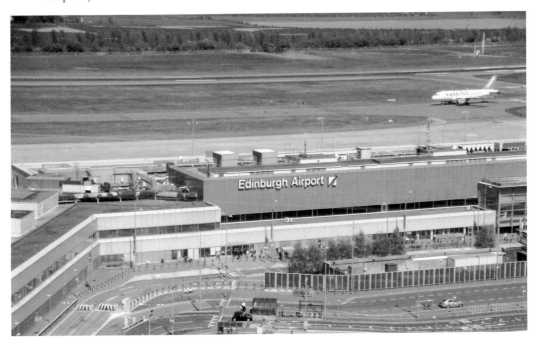

View of an easyJet A319 and the main terminal building on 26 May 2012. (Steven Campbell)

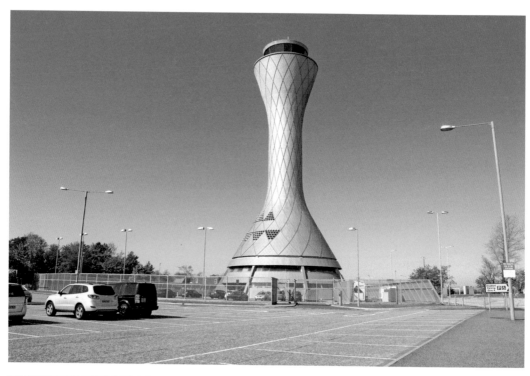

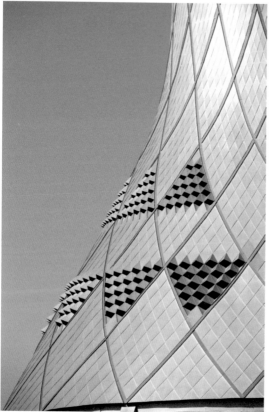

Above: The new ATC tower on 27 May 2012. (Aries Lang)

Left: Close-up of the tiled exterior of the new ATC tower on 27 May 2012. (Aries Lang)

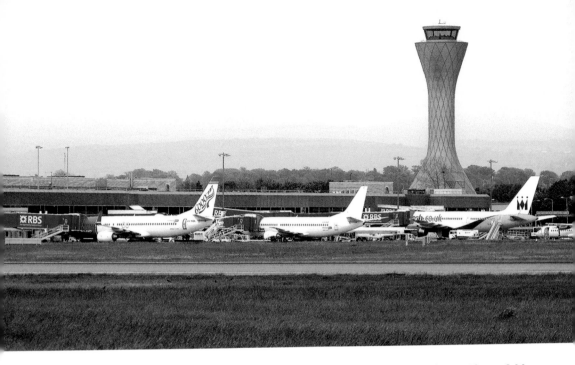

Norwegian Boeing 737s (LN-NOL and LN-KKO) with Monarch Boeing 757 (G-DAJB) on 28 May 2012. (Craig Smith)

A Norwegian Boeing 737 (LN-NOL) on 28 May 2012. (Craig Smith)

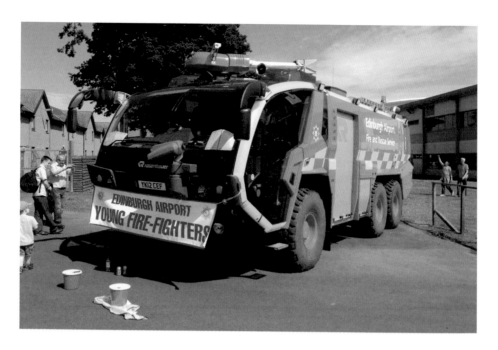

This Rosenbauer Panther (YK12 CEF) pictured at the Royal Highland Showground adjacent to the airport on 5 August 2012 was the first of three of this type at Edinburgh airport. The Edinburgh Airport Young Firefighters Association is a fire cadet scheme aimed at 13–18 year olds and is the only fire cadets' scheme based at a UK airport. (Andrew McNaish)

A Scania Viper (SN53 BNA) with the old BAA Fire Service badge on 5 August 2012. (Andrew McNaish)

easyJet G-EZFD holding position as G-EZUD lands on 13 August 2012. (Craig Smith)

Ryanair Boeing 737-8AS (EI-DLS) (wearing additional Comunitat Valencia stickers) landing on 13 October 2012. (William Jones)

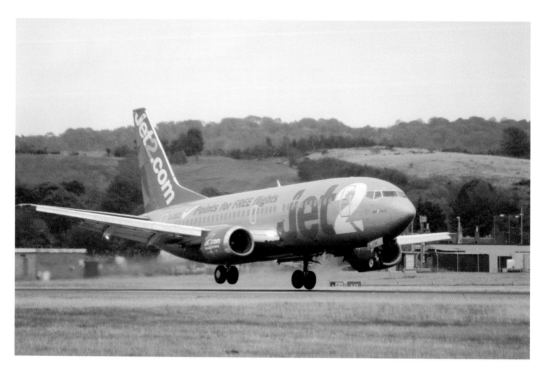

Jet2 Boeing 737-300 (G-CELZ) landing at Edinburgh airport on 13 October 2012. (William Jones)

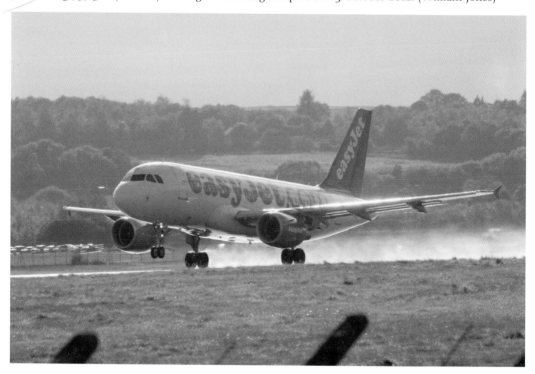

A wet take-off for easyJet Switzerland Airbus A319 (HB-JZF). This picture was taken from the River Almond on 14 October 2012. (William Jones)

A snow plough and gritter trying (unsuccessfully) to clear the taxiway on 6 December 2012. (Lesley Wilson)

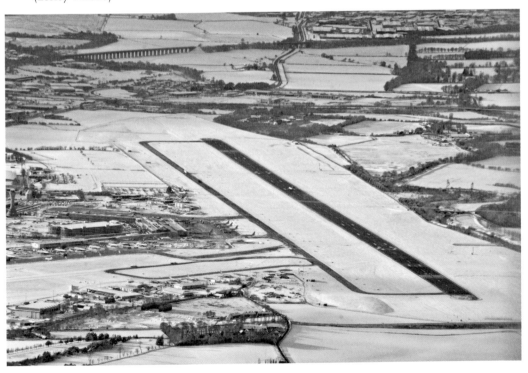

The airport just a few minutes after the airfield had been declared open after snow clearing. The first two aircraft to land can both be seen on the manoeuvering area. (Q3inq8-Flickr)

The Essex Caledonian Pipe Band at London Southend airport on 2 May 2013 for celebrations of the new daily easyJet service to Edinburgh. (Author's Collection)

easyJet Airbus A319-111 (G-EZFO) leaving London Southend airport on the inaugural flight of the new service to Edinburgh on 2 May 2013. (Author's Collection)